W9-AHA-244

SWEETIE™

SWEETIE

From the Gutter to the Runway

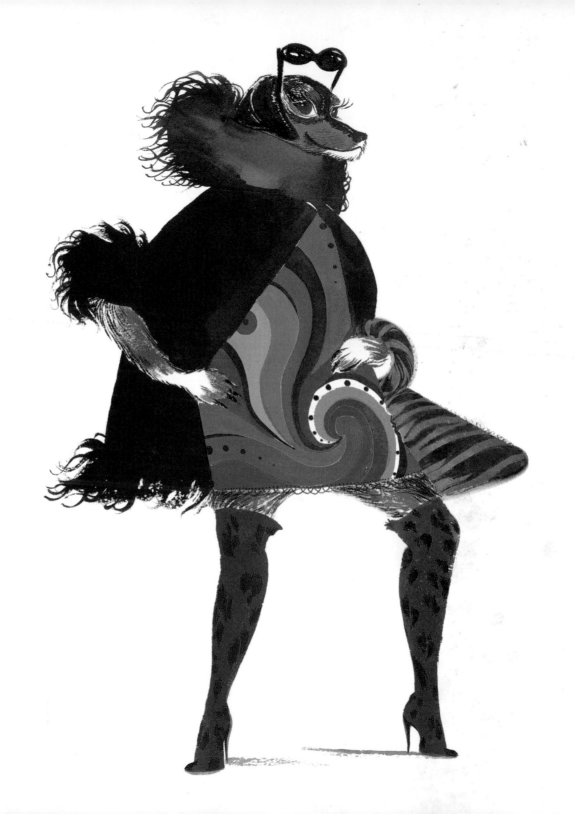

Sweetie

From the Gutter to the Runway

Tantalizing Tips from a Furry Fashionista

As told to MARK WELSH

Drawn by RUBEN TOLEDO

WARNER BOOKS

A Time Warner Company

Warner Books, Inc., 1271 Avenue of the Americas, New York, NY 10020

Visit our Web site at www.twbookmark.com

For information on Time Warner Trade Publishing's online publishing program, visit www.ipublish.com

 A Time Warner Company

Printed in Singapore

First Printing: September 2001

10 9 8 7 6 5 4 3 2 1

Library of Congress Cataloging-in-Publication Data
Welsh, Mark.
 Sweetie: From the gutter to the runway / Sweetie.
 p. cm.
 ISBN 0-446-52829-3
 1. Sweetie (Dog) 2. Dogs—New York (State)—New York—Biography. 3.
Fashion—United States—Humor. 4.Beauty, Personal—Humor. I. Title.
TT505.S95 A3 2001
746.9'2'0929—de21
 [B] 2001023369

Design by Memo Productions, New York

FOR MARK AND JOHN

And for underdogs (canine or otherwise) everywhere

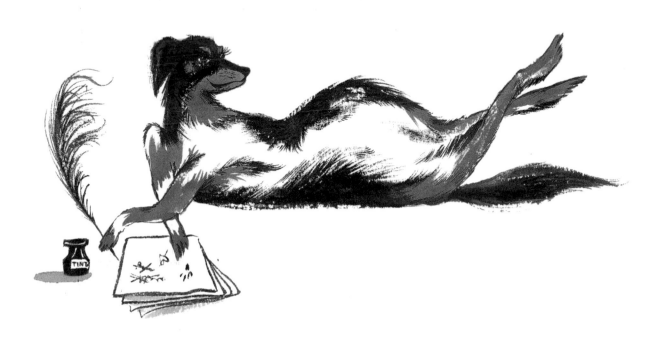

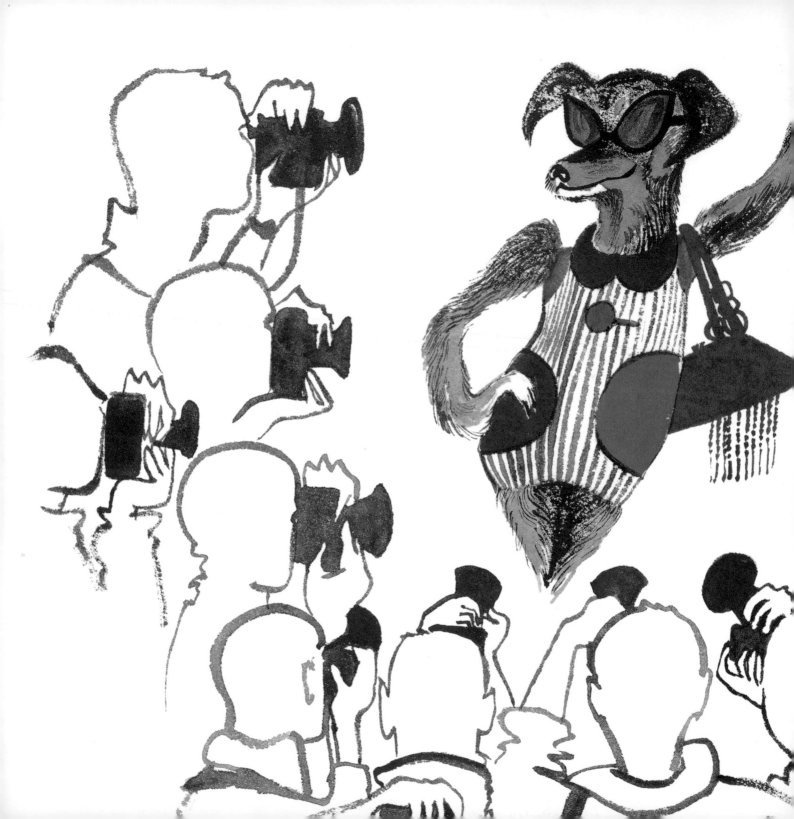

CONTENTS

INTRODUCTION

A hairy rags to riches story

It's often been said, dear reader, that the biggest difference between my story and Cinderella's is a couple of extra legs and a hairy midriff.

True, I come from a family heavily populated by ugly sisters (all of whom could use a good shave), but while Cinderella relied on pumpkins and princes to get to the top, I took an altogether different route. I chose fashion, or should I say, fashion chose me. Let me begin with a word or two about my bleak beginnings.

Once upon a time, long before I became a fashion icon, national treasure, living legend, and household name, I was just a hairy little mutt from the sticks. But then show me a major star who wasn't.

My family tree has more in common with a scraggly weed than it does a stately oak. Dad was the third of eleven children born of an one-eyed homeless hound called Blinky and a nameless bitch with a bad case of mange. And although my flea-bitten mother's parentage remains cloaked in mystery, local folklore has it that she was the only daughter of a three-legged chocolate poodle named Busty who had an insatiable fondness for plunging necklines and big, black Labradors.

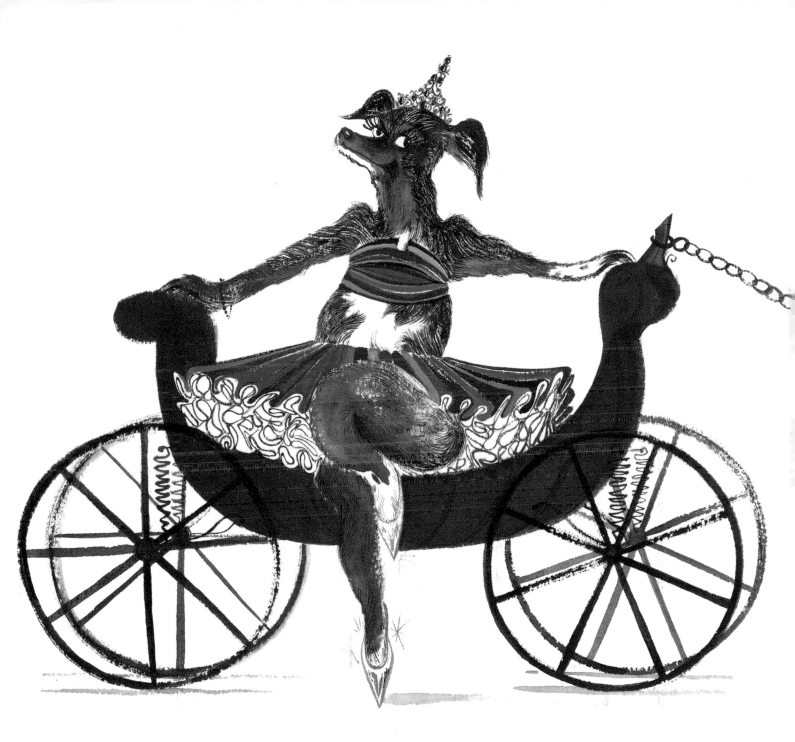

How did I triumph over my sordid past I hear you ask? How did I soar from squalor to superstardom? Mine is the rags to riches story of an underdog with a terminal case of bad breath and a dream.

My parents raised me far, far away from the glittering runways of Paris and Milan in a neighborhood that was decidedly lacking in glitter. We lived two hours north of New York City within the maximum security, minimum hygiene confines of a rural junkyard and beauty shop—"One-stop shopping for a hubcap and a perm" or so claimed the hand-painted sign framed with folksy razor wire curlicues. My summers were spent sipping imaginary glasses of Veuve Clicquot champagne in the shade of a rusted out '83 Pontiac and my winters were spent painting my nails in a four-poster

bed that I'd constructed out of sticks and a tattered wig. The husband and wife proprietors of the junkyard and beauty shop—"the Toothless" as I affectionately named them—were underwhelmed to have my precociously stylish self frolicking in their midst. When they weren't taking potshots at the broken-down lawnmower (they'd already shot the defenseless washing machine), they passed hour after hour hurling beer cans in my general direction. Perhaps it was my enviable ability to mix plaid and stripes that irked them so. Or maybe it was my insistence on speaking only French. I did everything I could to appease the Toothless, truly I did, but what talents could a wildly glamorous puppy possibly employ to soothe the volatile nerves of this scrap metal–selling, hot roller–toting twosome? I couldn't even open a beer.

Although I was trapped in a place where polyester was worn without irony, my fashion instincts were as sharp as a pleat. When the Toothless weren't using me as a moving target, I made hats from hubcaps and practiced my runway walk among the hairdryer carcasses that littered the yard. It was here, amid toxic heaps of empty peroxide bottles, that I first dreamed that a roast beef wearing a Chanel suit was chasing me through a sea of gravy. It was here among rusted refrigerators and worn-out washing machines that I created my ball gown made of license plates and rusted fenders. And it was here as I licked an empty can of Chef Boyardee pretending that it was a full can of foie gras that I reached a life-changing conclusion. If I was to

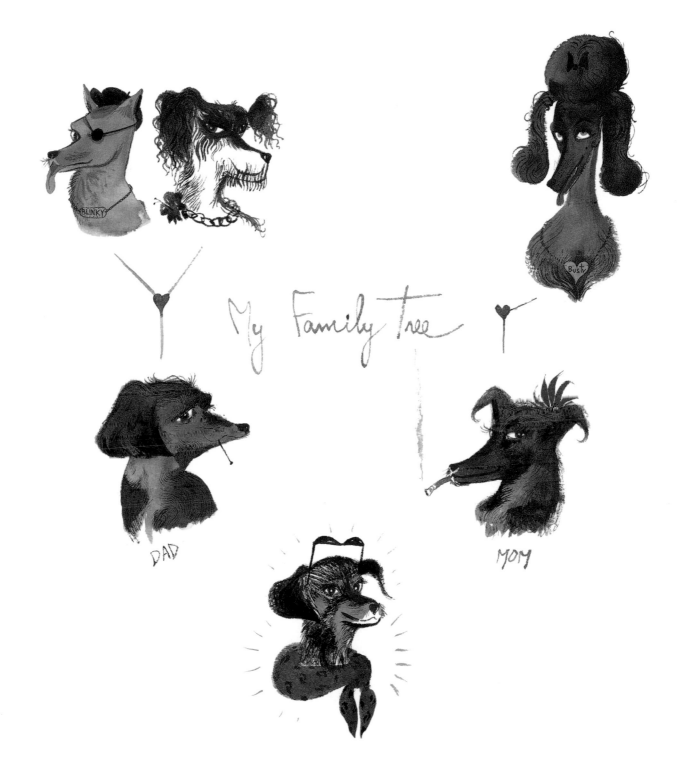

My Family Tree

DAD

MOM

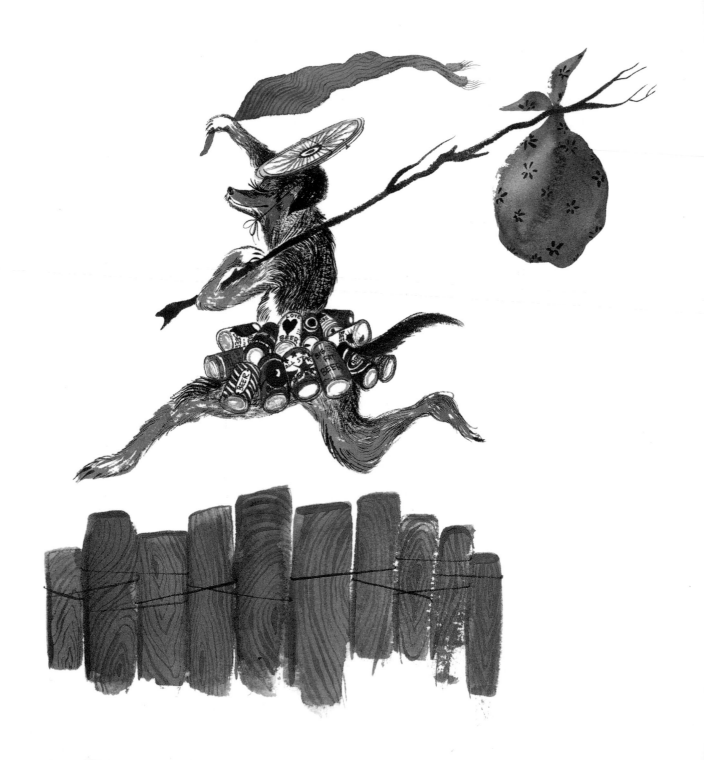

become an international fashion icon (and who could argue that this was my destiny?) it most certainly wasn't going to happen in the shadow of a burned-out '76 Chevrolet. I packed up my hubcap hats and beer-can ball gown, bid adieu to the junkyard I had so fondly-ish called home, and jumped the fence. My journey from the gutter to the runway was about to begin.

My small but intelligent head grew dizzy with excitement as I passed road signs that taunted me with the promise of an exciting new life: "Piglets 4 Sale," "Pump Your Own Gas," "Trespassers will be Shot." Five minutes later, the intoxicating aroma of freedom intermingled with road kill quickly lost its novelty and the hollow pit in my stomach began to echo like an empty Alpo can. Where was lunch? Sure, I'd learned how to bleach my own hair and make platform shoes out of broken blenders—who hasn't?—but these handy skills left me ill prepared to find roadside sustenance. For a brief, hungry moment, I yearned for the cozy familiarity of the junkyard—the sweet smell of Marshmallow Fluff sandwiches mixed with menthol cigarette smoke; the weekly outbursts of domestic violence followed by police interventions. Should I give up my dream of becoming a living legend, I wondered? Should I abandon my mission of becoming the most influential fashion figure of the entire twenty-first century? As these questions thrashed about in my small but intelligent head, I rounded a bend in the road and stopped dead in my tracks. My damp but intelligent eyes spied two men sitting on the porch of a yellow colonial farmhouse. The one I would come to call Mark (my future escort, bodyguard, and personal secretary) had protruding ears that any good mother would have pinned back at birth. The other man was wearing lime and navy plaid patchwork pants and a Brooks Brothers' shirt monogrammed with the initials J.B. He appeared to be sketching a fake fur bomber jacket. My heartbeat quickened. You see, dear reader, my keen fashion instincts told me that J.B. was actually John Bartlett, a prominent New York designer who had won the Council of Fashion Designers of America Designer of the Year Award twice. If I played my cards right, this lad in plaid could provide my entree to the exciting-ish world of international fashion. I took no chances. After boldly stepping onto the porch, I rolled onto my

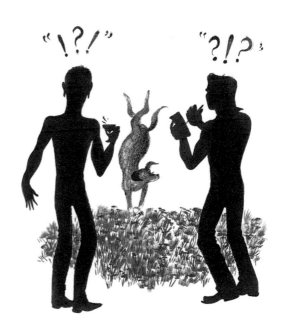

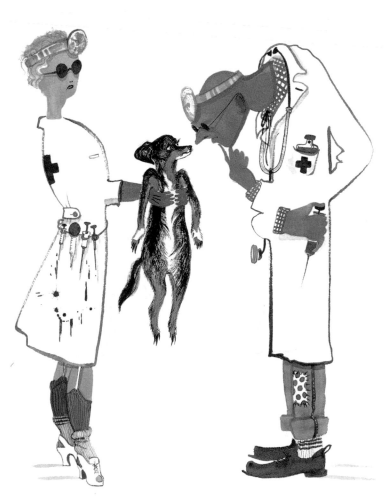

back baring my taut, terrific torso in Mark and J.B.'s general direction and shamelessly wagged my tail. J.B. looked up from his sketchpad. Mark looked up from his cocktail. Startled by my eerie beauty, they both stumbled backward. Evidently life in the junkyard had robbed me of my pretty years. With a sad assortment of chipped molars in the back of my mouth and a few fangs in the front, I was a living, barely breathing poster child for the needs of canine dentistry. (By the way, if anyone finds my missing teeth, I can be contacted through my publisher.) I weighed a waiflike seven pounds and was playing reluctant hostess to a hoard of fleas and ticks. With the exception of these freeloading insects, however, anyone could see that I had all the attributes of a top model—plenty of ribs showing, an empty stomach and a look of sad resignation on my small but photogenic face.

I located a pool of flattering late-afternoon light and stepped into it. "Love your patchwork pants," I said, buttering up J.B., my one-way ticket out of the sticks. "They'd go great with my hubcap hat."

The next morning, Mark and J.B. drove me to Doctor Harrison, the local veterinarian. Doctor Harrison was a kindly country gent who smelled vaguely of gin and formaldehyde. He assessed my condition carefully before announcing, "I think we should put her to sleep." Lord knows I could have used the rest, dear reader, but despite Doctor Harrison's suggestion, I was eager to move on with my new life. Mark and J.B. assessed my ravishing little self and made an instant

decision. "Let's adopt her as our hairy daughter," said Mark, plucking me off the ground and out of obscurity. "We'll call her Sweetie."

If you're anything like me, dear reader, and let's face it, with a shave and a wax we could be twins, your first glimpse of the Manhattan skyline filled you with a mixture of excitement, apprehension, and gas. I was thrilled to be thrust into the epicenter of the universe, but at the same time, several questions gnawed at the battered remains of what I laughingly called my self-esteem. Would those sophisticated New York City types snigger at my country bumpkin ways? Would I be just another hairy curiosity adopted and then discarded like countless others before me? Would I be seated front row at John's upcoming fashion show, I wondered? And if not, why not?

I had nothing to fear. Thanks to my red-hot connection to the white-hot fashion business, I was immediately handed an "admit one small, gorgeous mutt" pass to the glittering world of my dreams. It'd been just nine days, four hours, and seven minutes since my hauntingly lovely self had arrived on Mark and J.B.'s doorstep, and now here I was, a fashion icon, national treasure, living legend, and household name just waiting to happen. I wouldn't be kept waiting long.

Much to my delight, I was given a front row seat to all the major shows and an even more coveted backstage pass. During my frequent forays behind the scenes I learned/stole the grooming secrets of the makeup artists and hairdressers who created the most beautiful

FROM THE GUTTER TO THE GUTTER:
The early years.

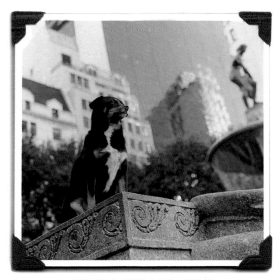

SMALL MUTT, BIG APPLE:
A country bumpkin arrives in the concrete jungle.

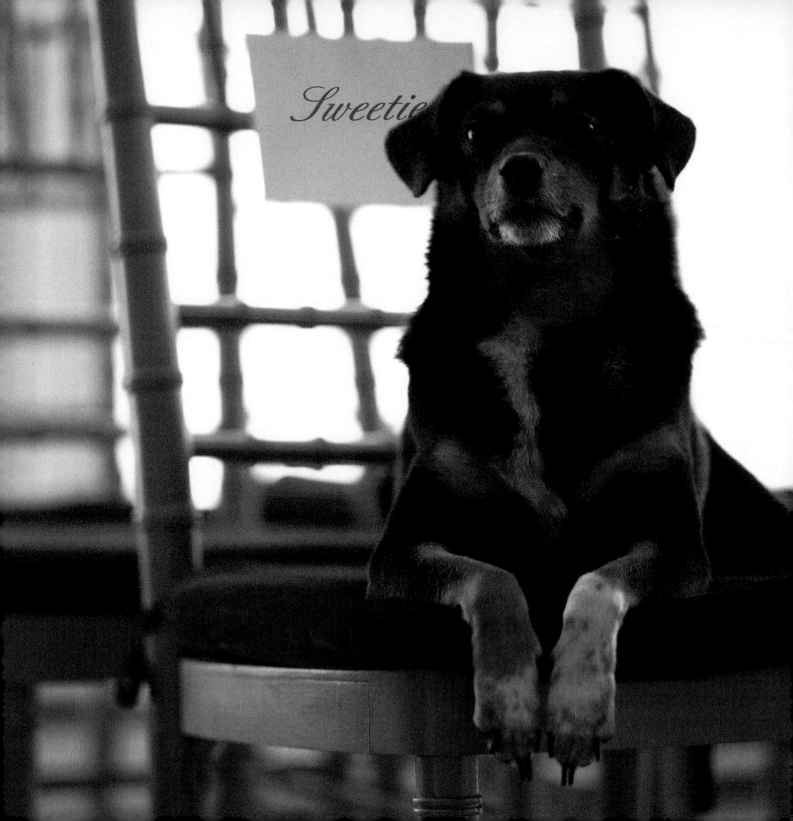

women (and me) in the world. I became the good luck charm of the supermodels and the consummate professional at stealing theirs and everybody else's limelight. Before I'd even learned to say "Ciao," I was jetting off to Milan for the European collections. I checked into the posh Hotel Principe di Savoia, where they immediately coined my regal room "The Sweetie Suite."

I was showered with gift baskets brimming with steaks. Weeping fans threw hams at me in the street. I learned exotic sounding new words like "pizza" and "soap," and developed an immediate and lifelong addiction to luxury fibers. Along the way my expert eye learned to distinguish gray from grey—you know how you do—and in a public proclamation that would upset both khaki and beige, I predicted eggshell would become the new cream.

Given my prominence as the hottest new dog in town, I was hounded by the paparazzi. After enduring excessive exposure to flashbulbs, my unusually proportioned profile surfaced in fashion publications from Tokyo to Sydney. My legion of lens men anointed me "The Hairy New Face of Fashion." Who was I to argue?

If I had a dime for every time someone said I looked like a Chihuahua-fox-terrier-doberman-gerbil mix, I'd have a dime. The truth is, dear reader, I don't look much like any dog, which is the secret behind my huge success as a photographic and runway model. My legendary career began when an agent from IMG models spied me shoplifting salami. Captivated by my eerie eroticism, he signed me immediately.

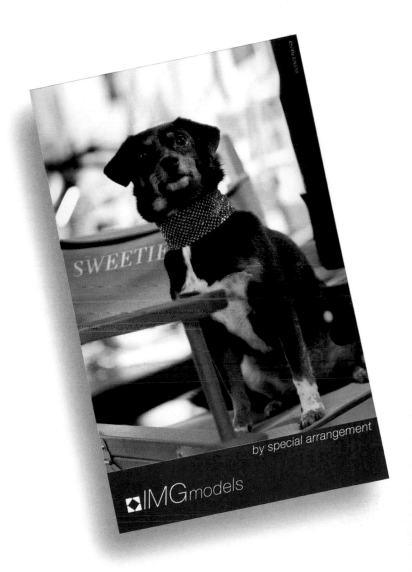

SWEETIE

by special arrangement

◻IMGmodels

How suite it is: Awaiting room service in "The Sweetie Suite" at…

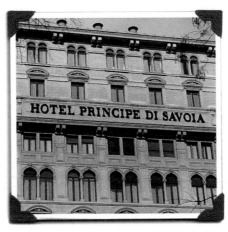

…Milan's Hotel Principe di Savoia.

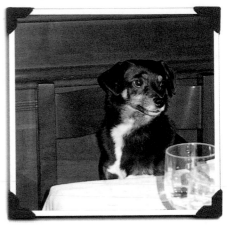

Carpaccio for small dog at table six: Lunching at Milan's fashionista hang out, Ristorante Bice.

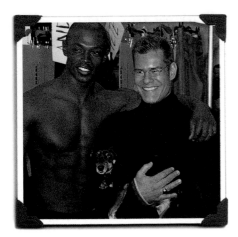

Say "Beef": Posing with John Bartlett and model Andre Brown.

Me with fellow IMG models, Kiara…

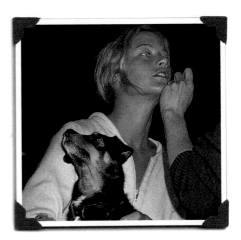

Carolyn Murphy,

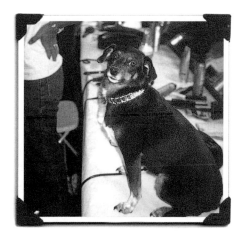

*Backstage Bedlam:
Surveying the scene through a
mist of hairspray.*

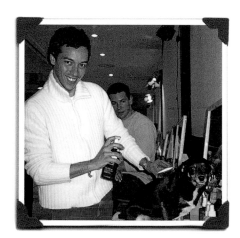

*Hair Stray:
Star hairdresser, Orlando Pita, gives
his hairiest client a comb out.*

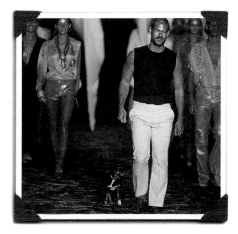

*Runway renegade:
Stealing the limelight from
designer John Bartlett.*

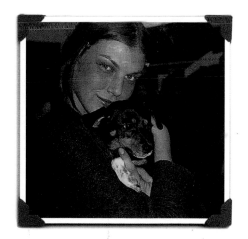

Angela Lindvall,

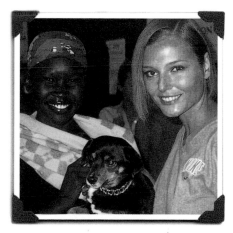

Alek Wek and Bridget Hall,

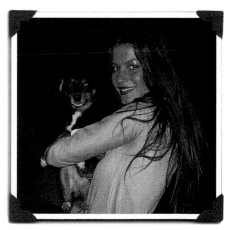

and Gisele Bundchen.

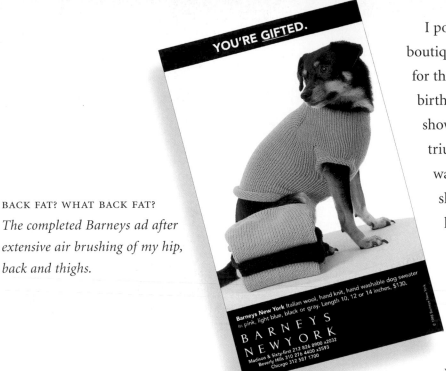

Barneys New York Italian wool, hand knit, hand washable dog sweater in pink, light blue, black or gray. Length 10, 12 or 14 inches, $130.

BARNEYS NEW YORK
Madison & Sixty-first 212 826 8900 x2032
Beverly Hills 310 276 4400 x5593
Chicago 312 587 1700

BACK FAT? WHAT BACK FAT?
The completed Barneys ad after extensive air brushing of my hip, back and thighs.

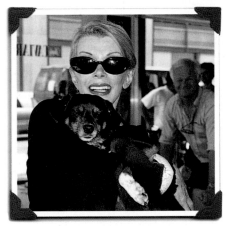

CAMERA, ACTION, SWEETIE!
With the great method actress, Joan Rivers, on the set of my first movie, The Intern.

I posed in two ad campaigns for the chic boutique, Barneys New York, walked the runway for the Chiquita Banana's one-hundredth birthday (what next, I wondered, a bridal shower for the Dole pineapple?), and took a triumphant turn down John Bartlett's runway during the finale of his spring fashion show. And yet like so many models that have had love affairs with the camera, I felt strangely unfulfilled. Perhaps what I needed was a bigger camera. I have frequently been compared to a young Elizabeth Taylor with a hairy midriff, and so I wasn't the least bit surprised when Hollywood came calling. I landed a (nonspeaking) cameo role opposite the great method actress Joan Rivers in the fashion flick *The Intern*. False modesty aside (yet again) it was a stunning debut. Critics raved that I have "a cinematic quality that's rare, especially among women with whiskers."

Fame turned me from a waif into a whale. Existing on nothing but organ meats, I soon developed my trademark mound of back fat. Plus-size girls the world over adopted me as their mascot and my pear-shaped body inspired the artist Ruben Toledo to create a line of fuller-figured mannequins. I embarked on a torrid affair with a massive bullmastiff called Bunky who liked his ladies chunky. Three weeks and countless pounds of stir-fried livers and kidneys later, Bunky discovered that my blood was less blue than muddy brown and

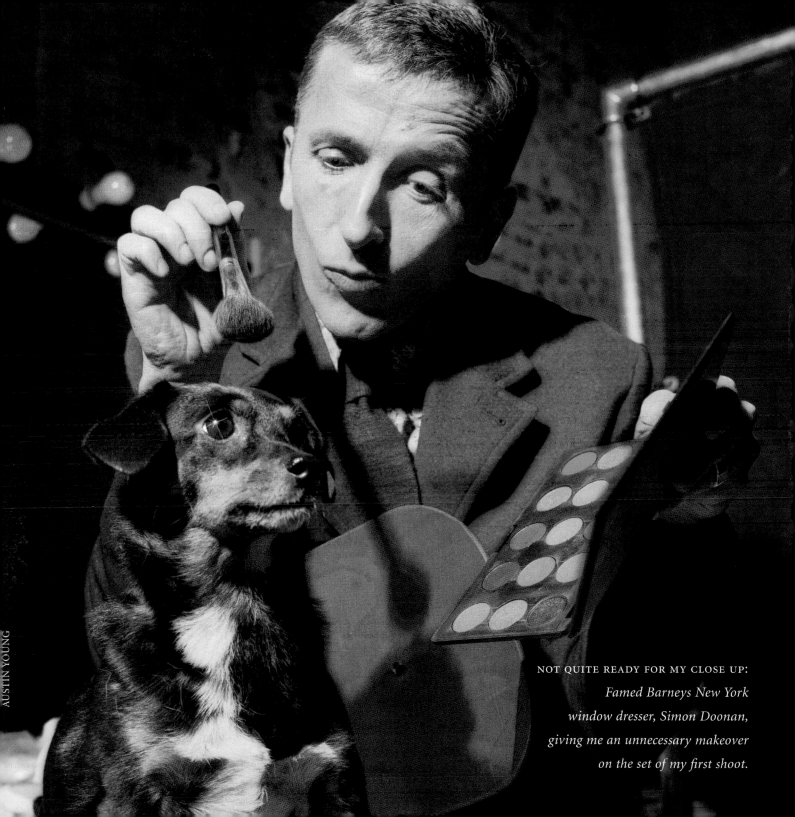

NOT QUITE READY FOR MY CLOSE UP:
Famed Barneys New York
window dresser, Simon Doonan,
giving me an unnecessary makeover
on the set of my first shoot.

dumped me. I retaliated by getting a tattoo that said "Mutts Rule" and became the spokesmodel for mixed-breed girls living in a purebred world.

In less than two years, I'd gone from underdog to top dog and had secured my place as fashion's most prominent four-legged insider. I was memorizing impressive sounding words from the *Oxford English Dictionary*—you know you how do—when I discovered a picture of myself alongside the word "fashionista." I was now officially defined as being a dedicated follower of fashion (in extreme cases, a fashion victim).

It seemed like only a matter of time before my irresistibly lickable face ended up on the front of a postage stamp. One day, while plotting how to get the Post Office to see things my way, the phone rang. "Sweetie," said the voice on the other end, "this is the editor-in-chief of *Elle* magazine." I suddenly felt poorly groomed and badly dressed. "We've been tracking your rise from mangy mutt to fabulous fashionista with great interest," continued *Elle*'s editor, "and we'd like to offer you your very own column." I wolfed down a steak and kidney pie and considered the proposition. "I'll do it on two conditions," I said polishing off a lamb chop soufflé for dessert. "I want a poodle and a Pomeranian as my personal assistants and an office with a view of the butcher." I should have held out for a limitless supply of bite-size goat entrail pastries. Poodles and Pomeranians were hired on the spot and contracts were signed with a flourish. I was the world's first and only canine columnist. Now all I had to do was learn to type.

PEAR SHAPED PERFECTION:
Showing off the results of my patented "fried bacon and no exercise diet."

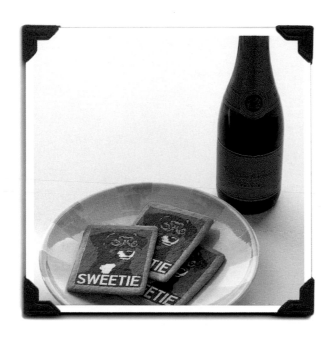

BISCUITS AND BUBBLY:
A.k.a. breakfast.

At a luncheon at Le Cirque 2000, *Elle* introduced their cunning carnivorous columnist (i.e., me) to those few members of the press who were still unfamiliar with both my extensive body and my extensive body of work. Naturally I avoided my salad.

Later that week, I was launched on an unsuspecting public with a glittering party at Barneys New York. Cookies bearing my logo in frosted hues of blue were served and my fascinating rags-to-riches tale was brought to riveting life in the store's celebrated Madison Avenue windows. There was no use denying it. Without the aid of princes or pumpkins, this hairy Cinderella had arrived at the ball and she was having a blast!

In my official capacity as *Elle*'s canine columnist, I took my adoring audience behind fashion's tightly drawn curtain and revealed the truth behind the constant mist of hairspray. The press called me "the funniest bitch on four legs." I couldn't have put it better.

My legion of fans leapt on my column like dogs hurling themselves onto meat trucks. Dozens of e-mails, illegibly scrawled letters, and even the occasional damp bar coaster crossed my desk every day—each one filled with flattering comments and/or desperate cries for advice. One day, as I was polishing off a heaping platter of organ meats, a gin-drenched paper napkin landed on my desk. This soggy communiqué would change my (and for that matter your) life forever. "Dear Sweetie," it began, "you've been gifted with humor, wisdom, rare beauty, a massive mound of back fat, and extraordinary humility"—the writer had amazing powers of observation!—"Please, oh please won't you tell your hugely inspirational story and share your insider tips on beauty, romance, diet, exercise, and stuff? You'd be doing women like me an invaluable service." My fawning fan had a point. I did have an inspirational story to tell and whether it was requested or not, I had plenty of vital advice to give. It was time to spill the beans. I turned on my computer, and after dusting some unidentified meat particles off the keyboard, wrote. . . .

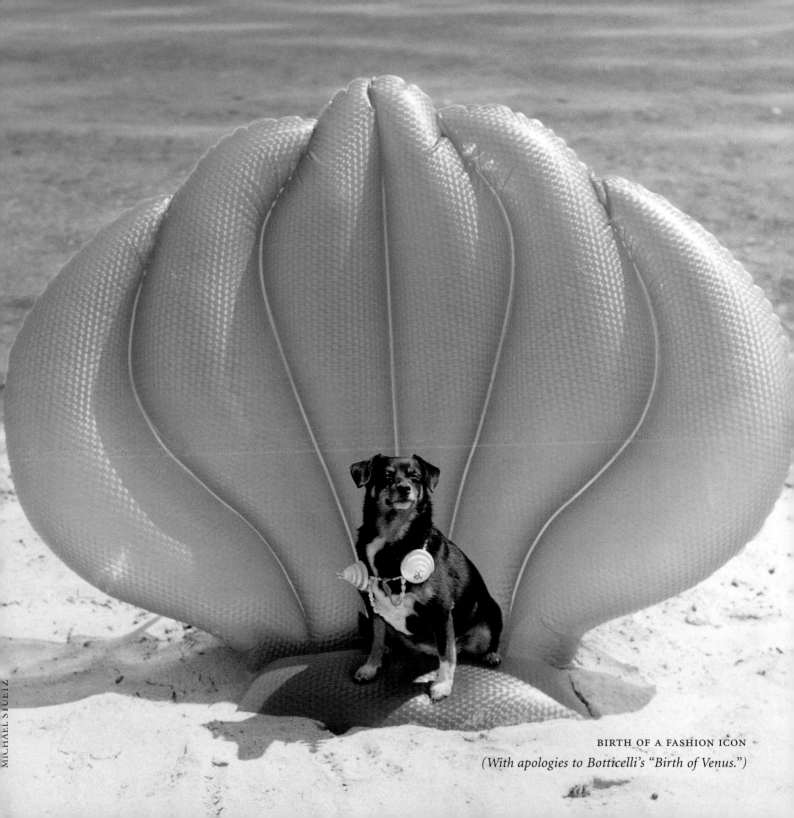

BIRTH OF A FASHION ICON
(With apologies to Botticelli's "Birth of Venus.")

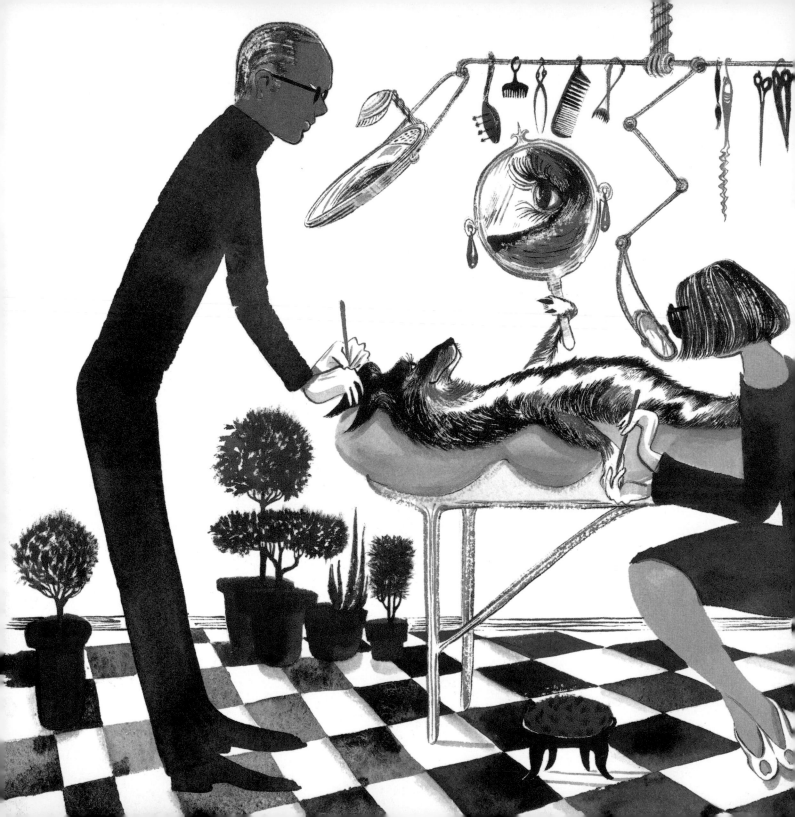

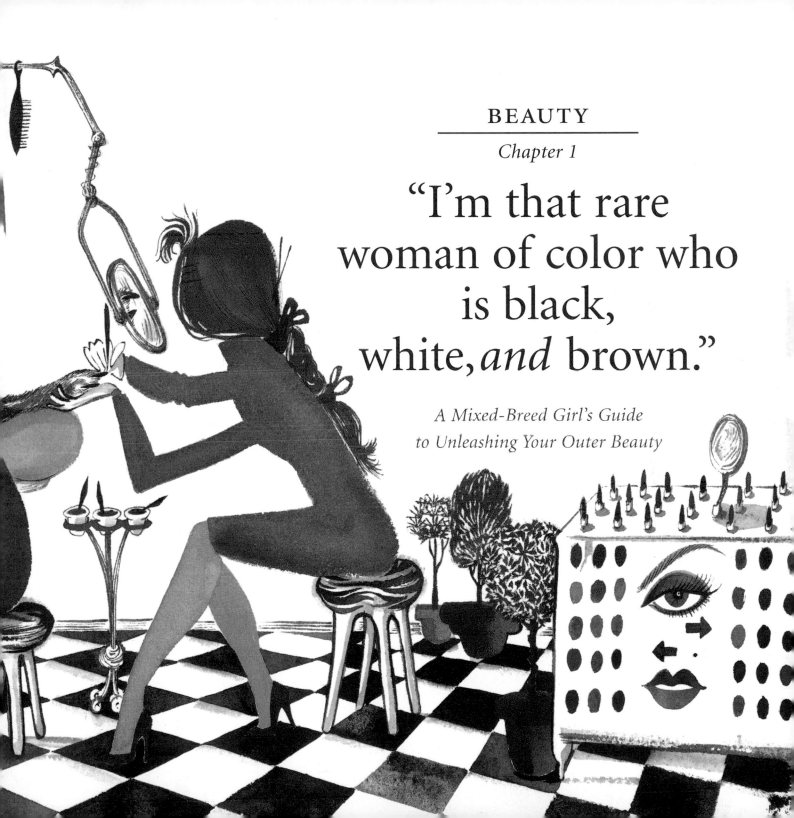

"I'm that rare woman of color who is black, white, *and* brown."

*A Mixed-Breed Girl's Guide
to Unleashing Your Outer Beauty*

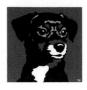

Anyone who says that true beauty lies within hasn't taken a good look at my intestines lately.

With the rare exception of myself, natural beauties aren't born, they're made.

I was applying my makeup with a shovel recently—you know how you do—when a beauty-expert friend described my exotic looks as "eerie" and "haunting." Others have gone so far as to gush that I have a face that would make an onion cry.

While no amount of plucking and primping will ever turn your face into one as acclaimed as mine, don't despair.

Jump aboard the Sweetie beauty bandwagon.

Together we can transform you from forgettable to fabulous!

SCARLET O'HARLOT:
*Putting my best foot forward behind
Elizabeth Arden's famous red door.*

I'M MORE THAN
JUST ANOTHER HAIRY FACE

Bringing out the beast, I mean best,
in every woman

If you look at the major models of the day, you'll notice that there's not a purebred in the litter. While these girls owe their exotic looks in part to their muddied gene pool, it's a little known fact that each and every one of them is also a graduate of The Sweetie School of Unfathomable Beauty. During this extensive two-minute course, I personally dispense pearls of wisdom to women of all skin tones and hair colors. For example, did you know that olive green lipstick is the most flattering shade for a redhead?

My Beauty Bible brings out the beast—I mean best—in every woman, no ands, ifs, or money-back guarantees about it!

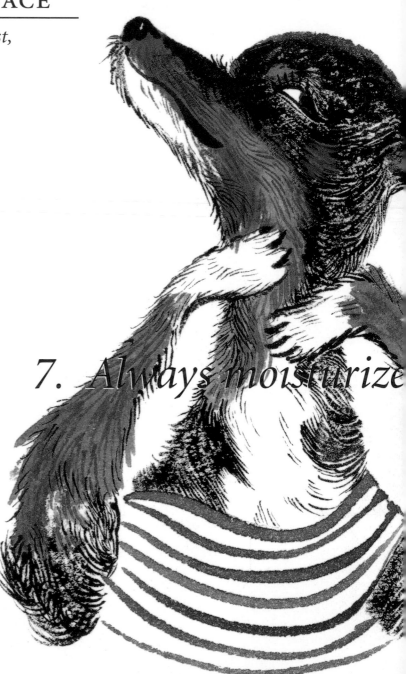

7. Always moisturize

BEAUTY BIBLE
MY TOP TEN COMMANDMENTS

1. Never put mascara on your teeth.

2. Braiding nostril hair draws attention to pretty noses.

3. Always dye your whiskers to match your shoes.

4. Prominent ears should be coaxed back with a hot glue gun.

5. Really prominent ears should be pinned back with a staple gun.

6. Disguise a tiny mustache problem by growing a full beard.

your neck. One day it could be your face.

8. Don't attach false eyelashes to lips.

9. Wear a fragrance made of turkey and gravy. *(What you don't use you can eat.)*

10. When in doubt, refer to my face for inspiration.

THE MOUTH SAYS MORE ABOUT YOU THAN ANY OTHER FEATURE
(unless it's wearing a muzzle)

How to turn lackluster lips into cupid's bows

Is your pout puckered out? Has your kisser lost its smooch?
Now you can ensure your lips send the right romantic
message by following these simple corrective procedures.

PROBLEM	SOLUTION
Uneven lips	Drink fewer cocktails before applying lipstick.
Small mouth	Drink several cocktails before applying lipstick. *(In my experience, this always gives you a big mouth.)*
Thin lips	Drinking too many cocktails frequently gets you a thick lip.

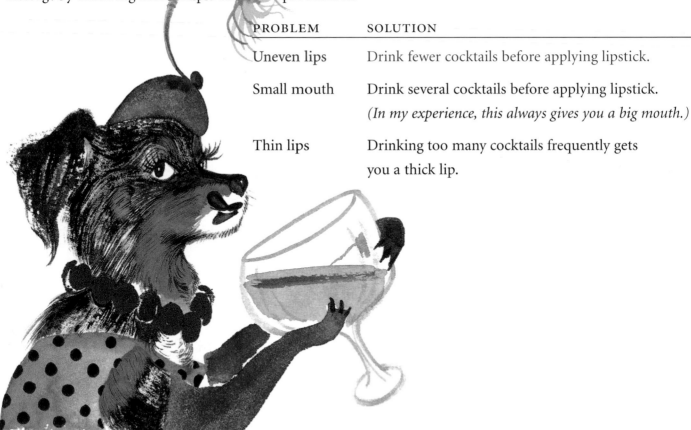

BEAUTY BRIGADE:
*My touch-up team of certifiable beauty professionals guarantees
that I'm never seen with a hair out of place.*

PATRICK J. MULLALI

SAVING FACE

The secret to maintaining your beauty?
Simply identify your favorite features
and insure them.

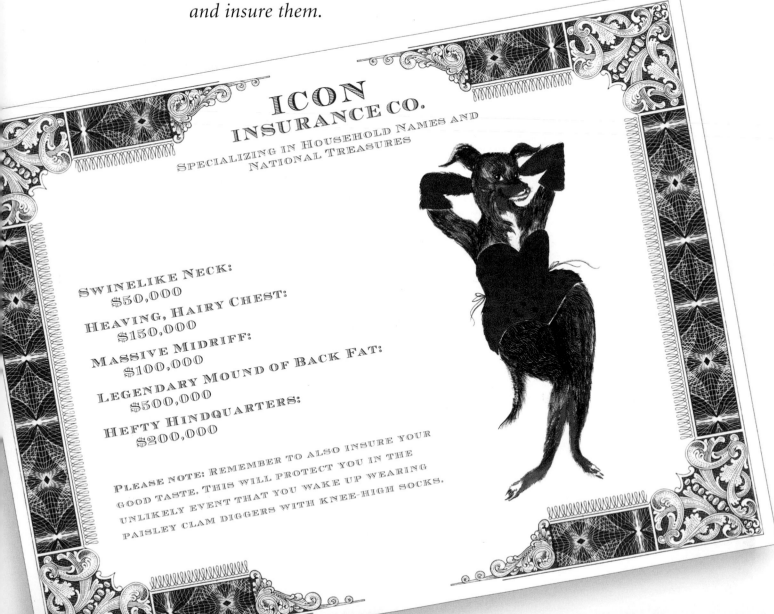

ICON INSURANCE CO.
SPECIALIZING IN HOUSEHOLD NAMES AND NATIONAL TREASURES

SWINELIKE NECK:
$50,000

HEAVING, HAIRY CHEST:
$150,000

MASSIVE MIDRIFF:
$100,000

LEGENDARY MOUND OF BACK FAT:
$500,000

HEFTY HINDQUARTERS:
$200,000

PLEASE NOTE: REMEMBER TO ALSO INSURE YOUR GOOD TASTE. THIS WILL PROTECT YOU IN THE UNLIKELY EVENT THAT YOU WAKE UP WEARING PAISLEY CLAM DIGGERS WITH KNEE-HIGH SOCKS.

IF EYES ARE THE WINDOWS
TO THE SOUL THEN EYEBROWS
ARE THE DRAPES

Turning your eyebrows into eye wows!

With a little taming, your "bushiest beauty assets"
have unlimited potential to convey a variety of
emotions—a talent much envied by the nose and chin.

THE
MIXED MESSAGE
LOOK

THE GETTING
AWAY WITH MURDER
LOOK

THE
QUIZZICAL
LOOK

THE "WHO THREW
THE CHICKEN AT ME?"
LOOK

MASKING YOUR BEAUTY

Sometimes you have to hide face to save face

If you're anything like me—and let's face it, we're as similar as two chops
on a rack of lamb—you learned long ago that mud-based beauty masks
don't work well on girls with hairier complexions. Mud gets stuck in your
whiskers and clogs up your paws. This is why I developed my scientifically
unproven line of beauty masks especially for furry faces. My miracle masks
provide dual benefits. Not only do they make you look minutes younger,
they also scare the pants off children at Halloween!

SWEETIE'S FABULICIOUS FACIAL

1. Locate a pool of sunshine and curl up on a favorite cushion.

2. Apply "beauty mask."

3. Sleep for 72 hours without interruption.

4. Remove mask.

5. Admire refreshed, youthful complexion.

MICHAEL STUETZ

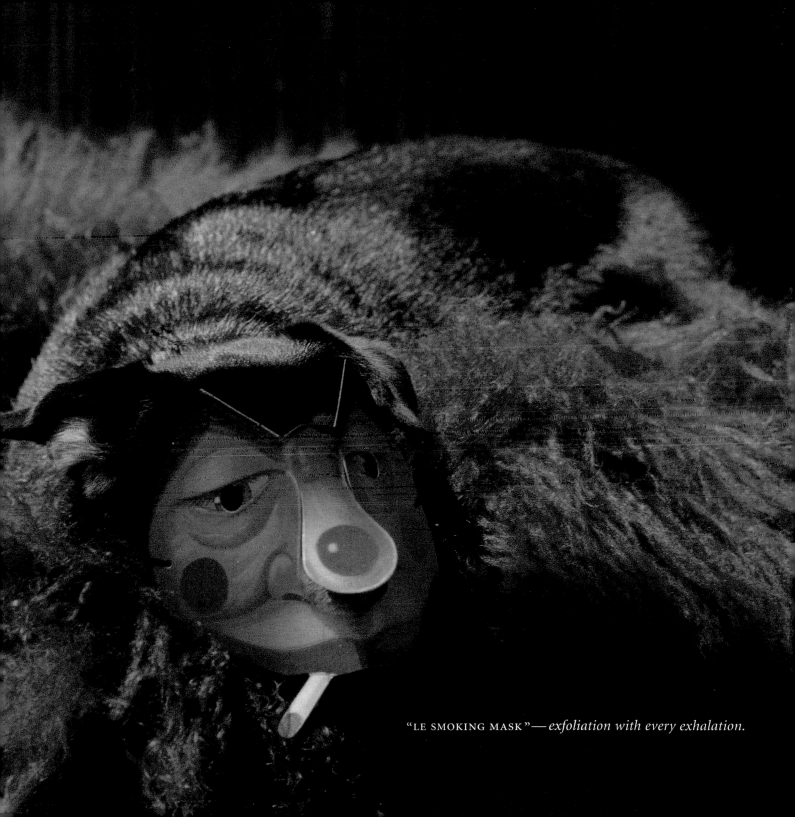

"LE SMOKING MASK"—*exfoliation with every exhalation.*

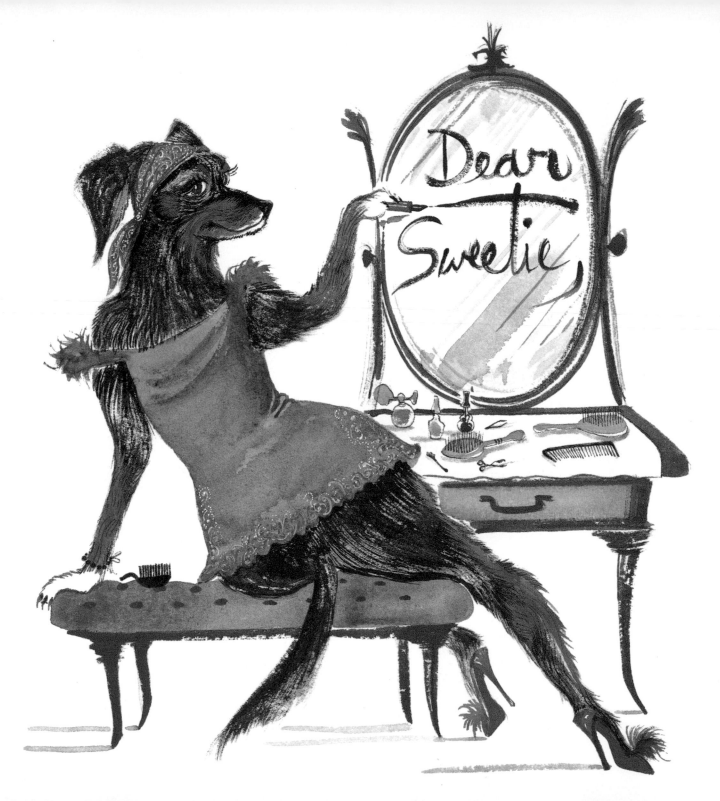

Dear Sweetie,

I apply expensive creams morning and night and still I have wrinkles.
Is there any way to get rid of them?

"Have you tried a hot iron?"

Where do you stand on the age-old adage "beauty is only skin deep"?

"In the words of one of my close-ish friends, 'while beauty may
be only skin deep, ugly goes all the way to the bone.'"

Is there any way for me to get a complexion that's
as fresh and moist as morning dew?

"Sleep outside."

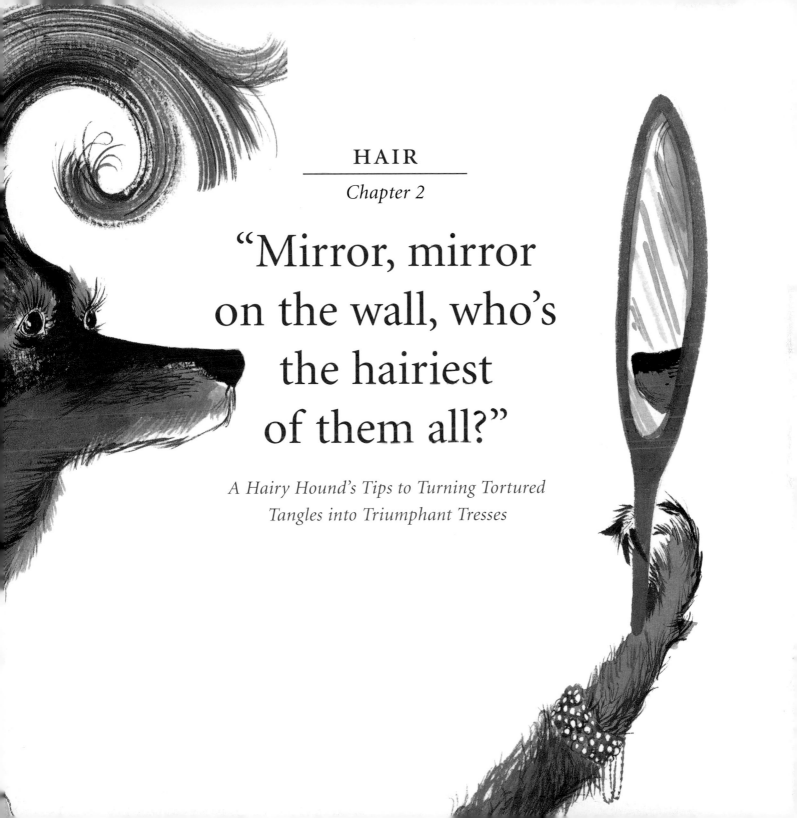

Chapter 2

"Mirror, mirror on the wall, who's the hairiest of them all?"

A Hairy Hound's Tips to Turning Tortured Tangles into Triumphant Tresses

I haven't always been the patron saint of hairdressers, dear reader. Long before I became a global style icon and roving hair model, I was just another furry nobody with a matted coat and a toothless comb.

How quickly things change in the high stakes world of hair.

I was braiding my back hair recently when a tour group of hairdressers arrived at my door and offered good money just to brush me. It seems that a single touch of my gleaming coat can inspire even the lowliest barber to greatness.

Chances are that your hair (unlike mine) won't go down in "hairstory" for inspiring the next flip or bouffant.

But if you pick up your scissors and follow my "hairsterical" advice, together we can turn those tortured tangles into your very own crowning glory.

DIAL W FOR WIG

The end of the bad hair day

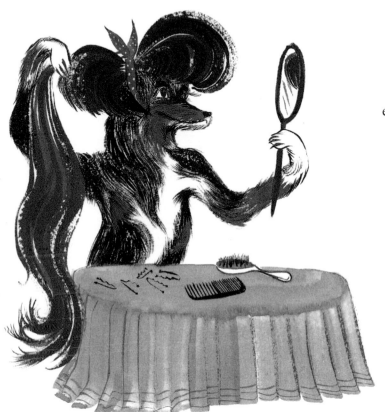

Believe it or not, dear reader, there are certain days when even my heralded hair loses its legendary loveliness. When my locks lack luster and my sheen turns green, I do what hair icons throughout the course of history have done. I dial W for Wig.

Wigs are your hair's most invaluable understudies— bit players that never frizz or sag. If you feel like being a blonde for the day, pop on a platinum helmet. If you're raring to reach the redhead within, don some fiery fake follicles.

A word of warning from the professional wig wearer (i.e., me) to the novice wig wearer (i.e., you): While wig wearing is still an amateur sport, certain rules prevail.

1. Wear hairpieces on roller coasters at your own risk.

2. Under no circumstances attach blonde ponytails to brunette falls.

3. Don't drink and wear wigs.
Cocktails cause hair that's not your own to wilt.

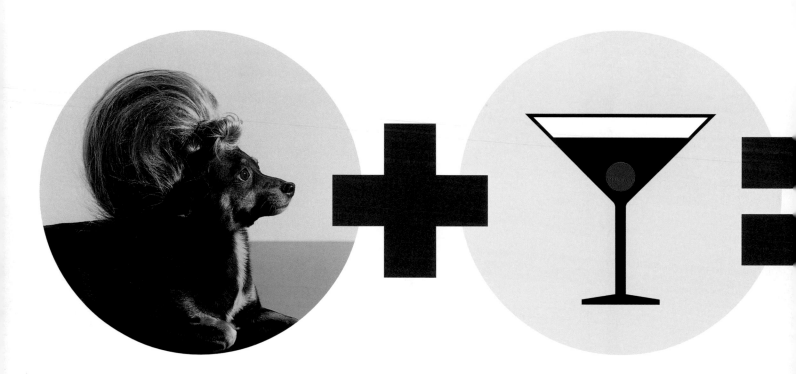

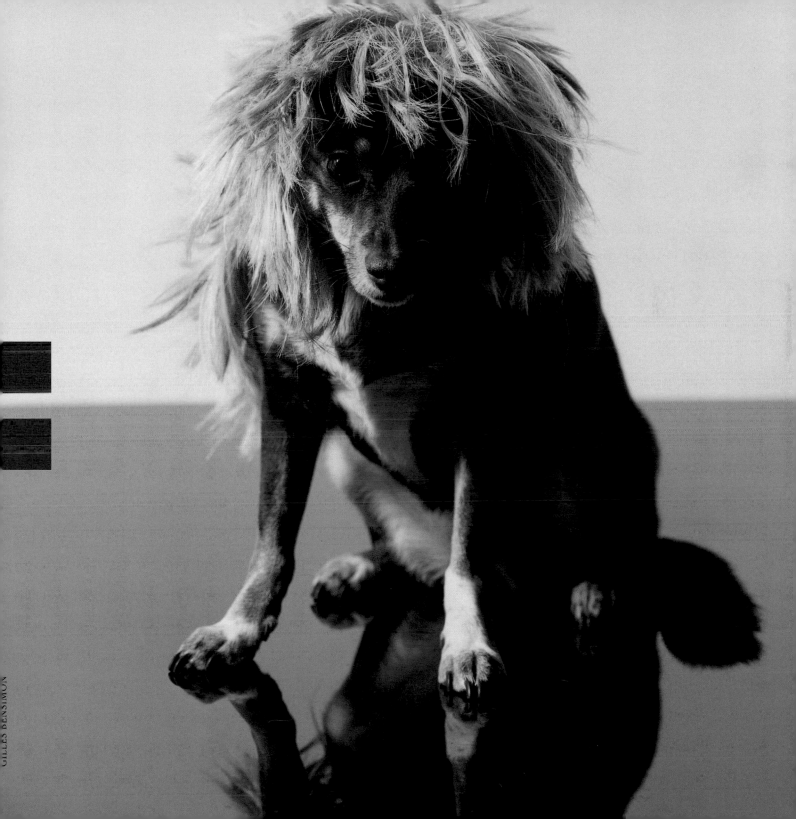

DRY IT AND FRY IT BUT DON'T MAKE IT DIET

A compassionate case for feeding your hair

Have you ever asked your ponytail if it would like a nice rare T-bone? Have you ever made a sandwich for your braids? Of course you haven't. You expect your hair to stay strong and silent and then reward it by frying it and dyeing it.

Put the bounce back in your bangs and say "gee, thanks" to your hairiest asset by feeding it a heaping helping of my Coif Conditioning Concoction.

SWEETIE'S INDUSTRIAL STRENGTH COIF CONDITIONING CONCOCTION

Combine the following ingredients in a concrete mixer and apply one shovelful directly to the hair three times daily.

· 40 pounds chopped liver (to nourish hungry roots)

· A heaping wheelbarrowful lawn fertilizer (to promote new growth)

· 20 gallons high gloss house paint (to restore everlasting shine that won't chip or fade)

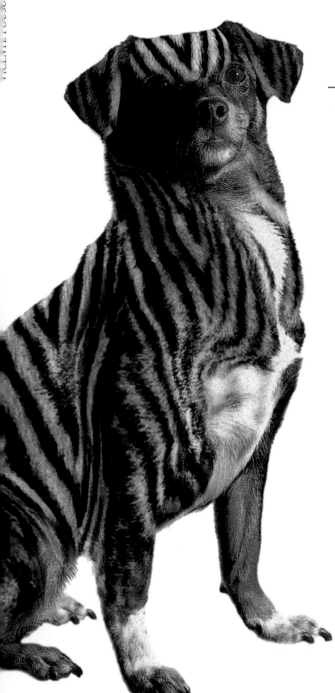

HAIR TO DYE FOR

How to put on (and pull off) a coat of many colors

Ever since I was a young pup I've been proudly denying my roots. My natural hair color—black with gorgeous brown and white highlights—is perfectly dazzling for everyday wear. But on those everyday occasions that I need all eyes focused on me, I prefer to put on a coat of a different color, spot or stripe.

Follow my wildly exotic example, dear reader, and remember… mousy brown is for mice!

"The Indognito"—Low profile locks that keep the paparazzi off my scent.

DOGGIE STYLE

*A salon superstar shares
her headline-making hairdos.*

"The Three Dog Night"

A triple coif combo special
that gives you
more bangs for your buck.

"The Dog Days of Summer"

Set the "hair conditioning"
to cool with
this short back and sides.

"The Big Tease"

The bigger the hair, the closer to heaven.

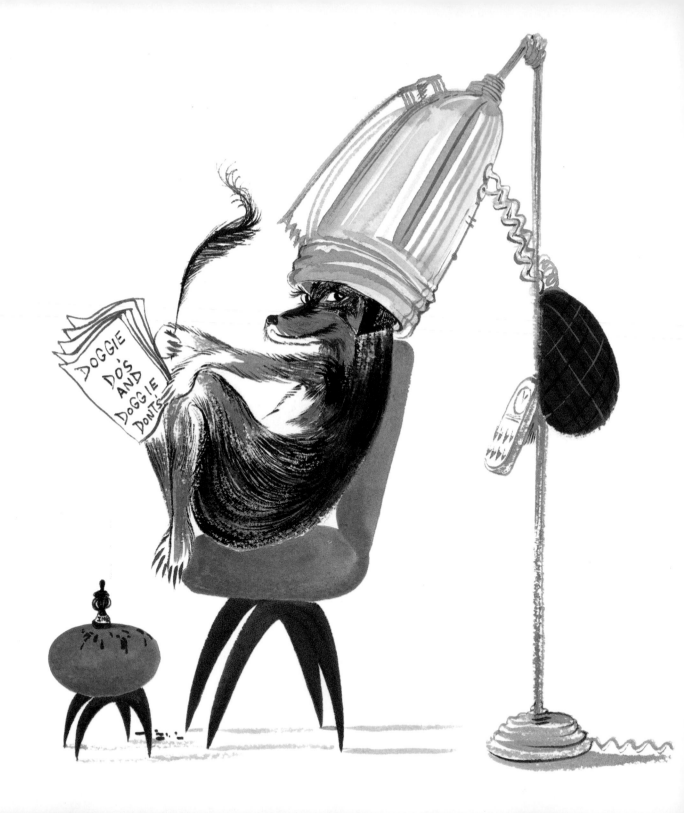

 Dear Sweetie,

I've been thinking of dying my hair platinum blonde to put some
va-va-voom into my mousy brown social life. Is it true that
blondes have more fun?

"Not if you throw a bucket of water on them."

I like to dress up my hair when I go out on a date.
Are there any particular hair accessories that turn men on?

"Nothing says sexy like a tasteful (and tasty)
pair of pork chop barrettes. If these don't have
him licking his chops, try wearing a side of
beef as a hat."

I'm mad about fifties fashion.
Do you think it's time to revive the Beehive?

"The only thing that looks
good in a beehive is a bee.
Don't get stung!"

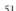

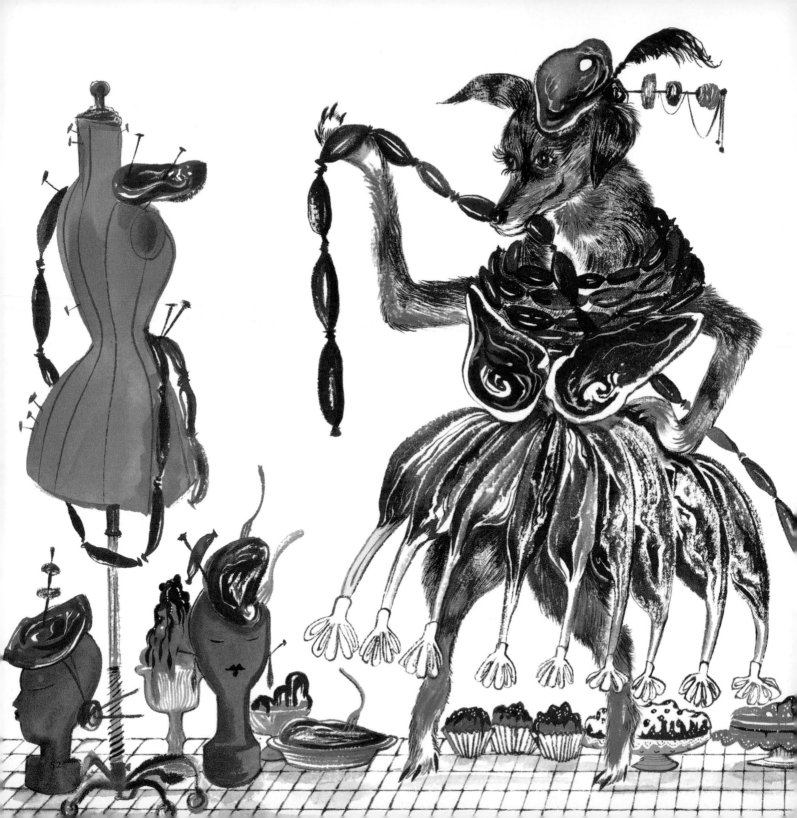

DIET

Chapter 3

"You are what you eat."

*A Curvaceous Carnivore's Guide to Putting
Some Meat on Your Bones*

It's a little known fact, dear reader, that Cæsar regularly wrapped his bunions in healing rashers of bacon.

Few people know that Ivan the Terrible soothed his wicked temper by wrestling bulls to the ground and gobbling them whole. And while it has been widely reported that Marie Antoinette said, "Let them eat cake," her actual words were "Let them eat steak."

The proof is in the pork chop.

Whether it baaas, mooos, clucks, or oinks, meat in its many mouthwatering manifestations has been solely responsible for creating history's most memorable figures. Just look at mine!

TURNING VITTLES AND VARMINTS INTO VITAMINS

In praise of the protein pyramid

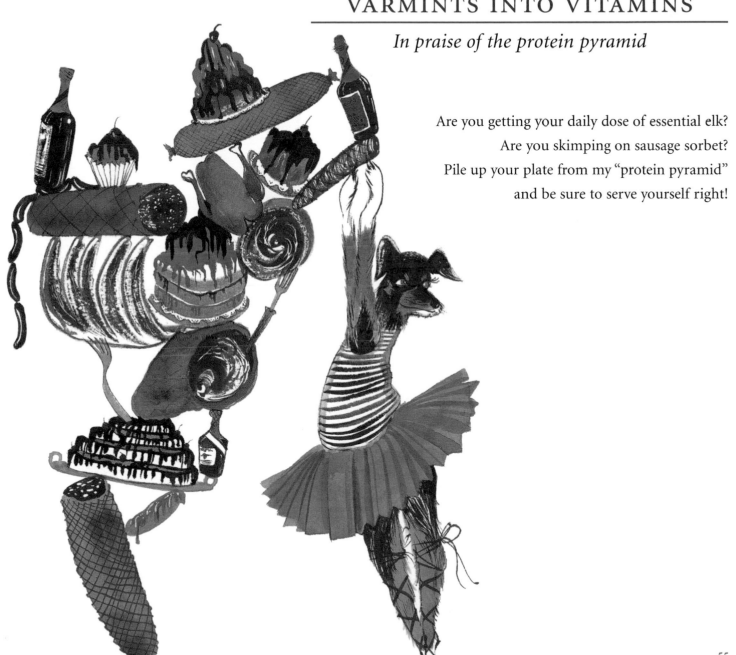

Are you getting your daily dose of essential elk?

Are you skimping on sausage sorbet?

Pile up your plate from my "protein pyramid"

and be sure to serve yourself right!

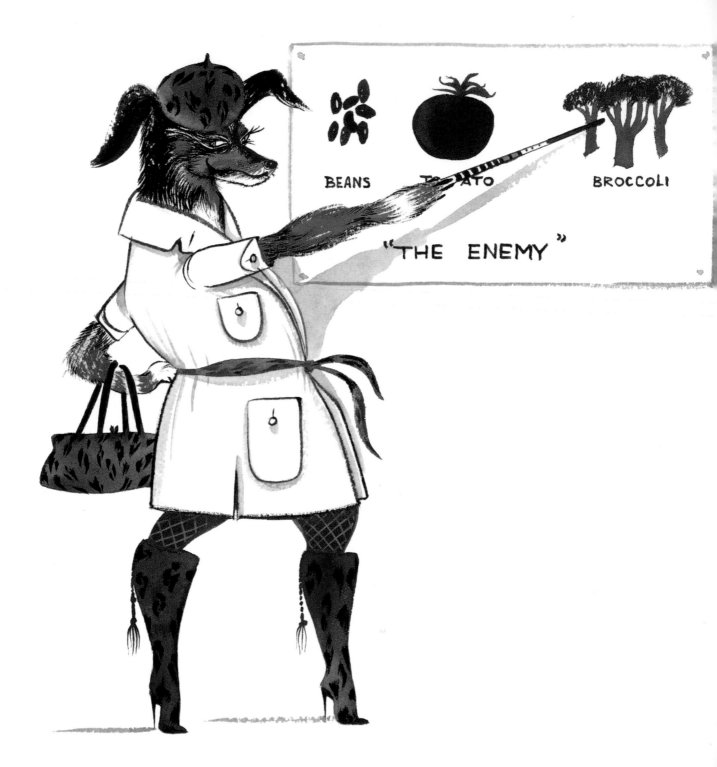

DO I *LOOK* LIKE A VEGETARIAN?

Waging war against the green menace

Back when I was a mere pup, I suffered an allergic reaction to a sprig of parsley, the almost fatal symptoms of which included confusing polyester with silk and thinking that I actually looked good in polka dots! I never fully recovered. To help protect you against the green menace (not to mention polka dots), I've created my internationally acclaimed Manifesto of a Meat Eater. Carry it with you at all times. Refer to it often. And remember, never leave home without a sausage in your pocket. It's the only known antidote to parsley poisoning!

MANIFESTO OF A MEAT EATER

1. Cozy up to cows. They're buffets in the making.

2. Never wear green. This is the code color vegetarians use to signify their mutual love of zucchini.

3. Salads are a heart attack waiting to happen. It's a little known fact that a single lettuce leaf contains more cholesterol than an entire side of beef!

4. A steak is to a vegetarian what a stake is to a vampire. Ward off vegetarians by traveling with a purse full of T-bones.

5. Olives may be added to martinis, but only for a splash of color!

LIVING LEGENDS CAN'T SURVIVE ON MEAT ALONE

How a big-boned booze hound drinks her calories

What do Shirley Temple, Tom Collins, the Virgin Mary, and myself have in common? Apart from the fact that we're all household names, each of us has a cocktail named in our honor.

Given that I'm pound-for-pound at least twice the size of these other celebrities, it makes perfect sense that I have inspired not just one but two drinks—The Dog Days Daiquiri and The Puppuccino. Due to the vast number of calories in both, I highly recommend serving them as meal replacements to guests. Bottoms up!

THE PUPPUCCINO

Make one cappuccino using heavy cream. Garnish with lamb chop sprinkles to taste. Throw out the coffee and lap up the froth.

THE DOG DAYS DAIQUIRI

Mix 1 1/4 ounces each of rum, lime juice, and salami-flavored syrup. Shake with ice and serve in a cut-crystal dog bowl. Garnish with wedges of filet.

THE MIRACLE ORGAN MEAT DIET

A fuller-figured girl's guide to building up your back fat

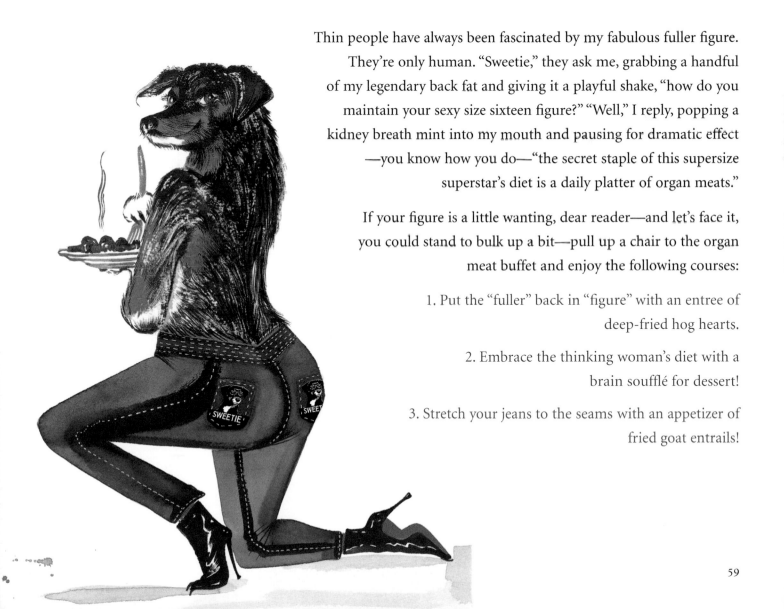

Thin people have always been fascinated by my fabulous fuller figure. They're only human. "Sweetie," they ask me, grabbing a handful of my legendary back fat and giving it a playful shake, "how do you maintain your sexy size sixteen figure?" "Well," I reply, popping a kidney breath mint into my mouth and pausing for dramatic effect —you know how you do—"the secret staple of this supersize superstar's diet is a daily platter of organ meats."

If your figure is a little wanting, dear reader—and let's face it, you could stand to bulk up a bit—pull up a chair to the organ meat buffet and enjoy the following courses:

1. Put the "fuller" back in "figure" with an entree of deep-fried hog hearts.

2. Embrace the thinking woman's diet with a brain soufflé for dessert!

3. Stretch your jeans to the seams with an appetizer of fried goat entrails!

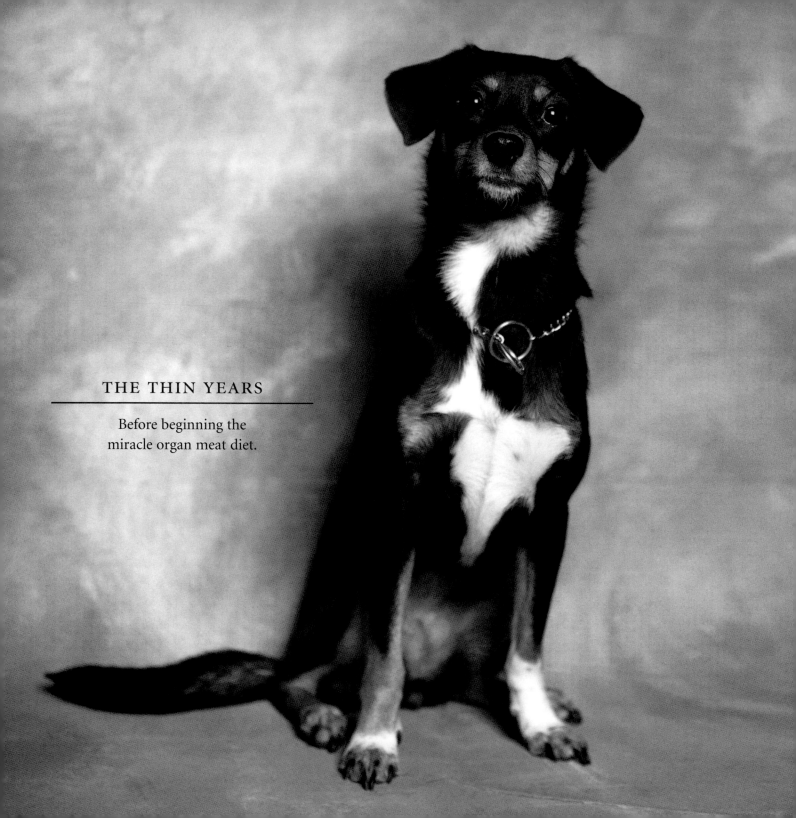

THE THIN YEARS

Before beginning the
miracle organ meat diet.

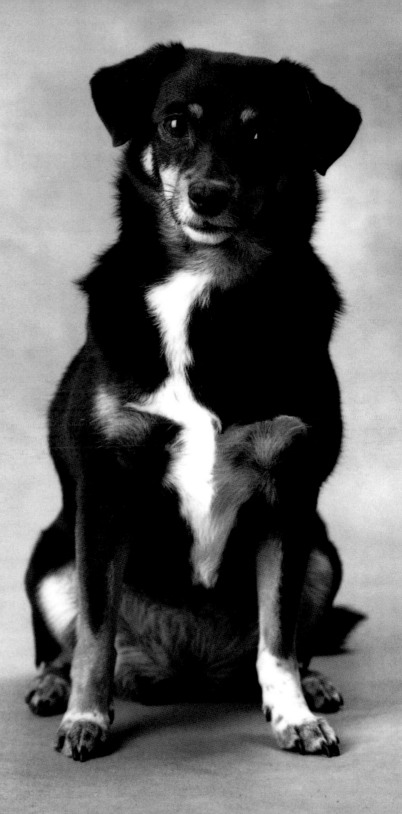

THE "HAVEN'T BEEN
THIN IN WEEKS" YEARS:

After just two weeks
on the miracle organ meat diet!

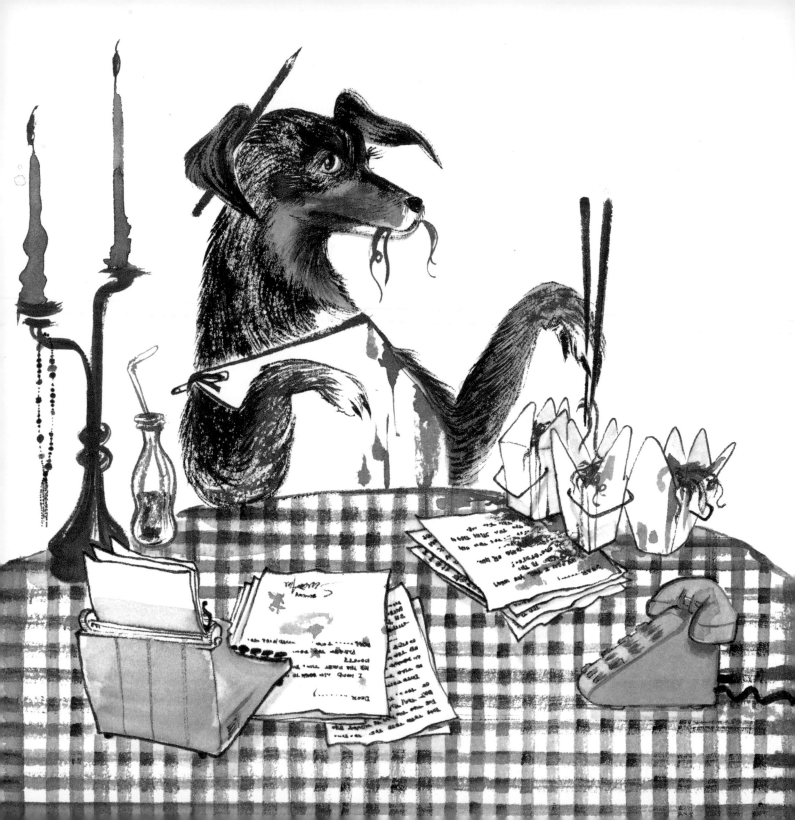

Dear Sweetie,

I was at a hot tub party in the Hollywood Hills recently, when someone spiked my drink with a roast beet. My tongue swelled up and I couldn't pronounce vowels. Is there an antidote to beets?

"After exhaustive research I've discovered that the only antidote to roast beets is roast beef."

Although I'm a devout meat eater, I'm also partial to fish. Where do you stand on "the catch of the day?"

"If it swims, throw it back."

I'd like to start a meat fan club. Any ideas on how I should begin?

"Begin by getting your priorities straight. Before you start a meat fan club, shouldn't you begin a long overdue Sweetie fan club?"

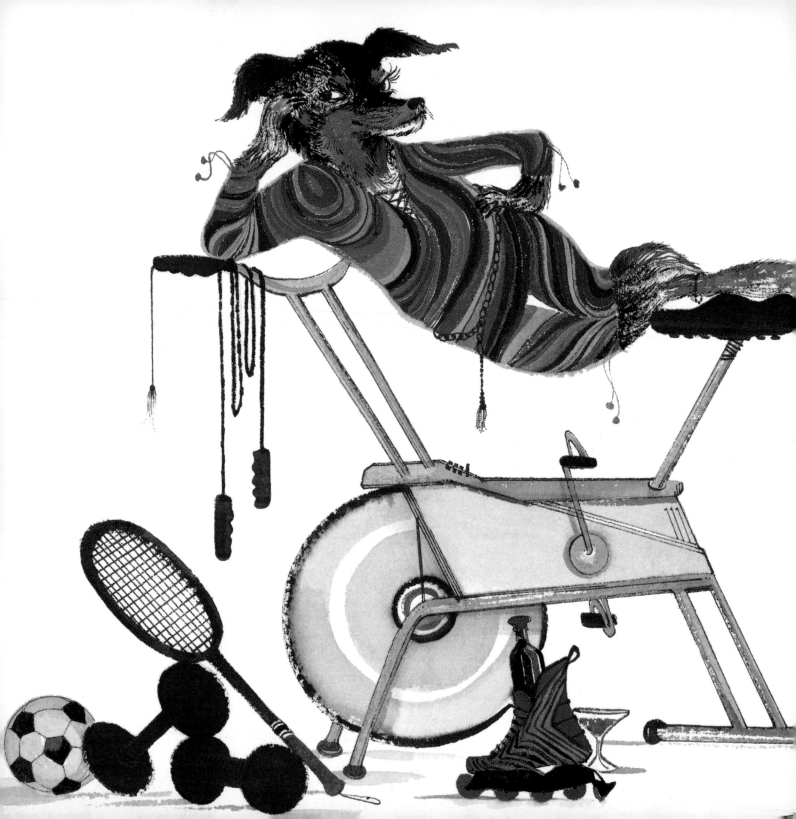

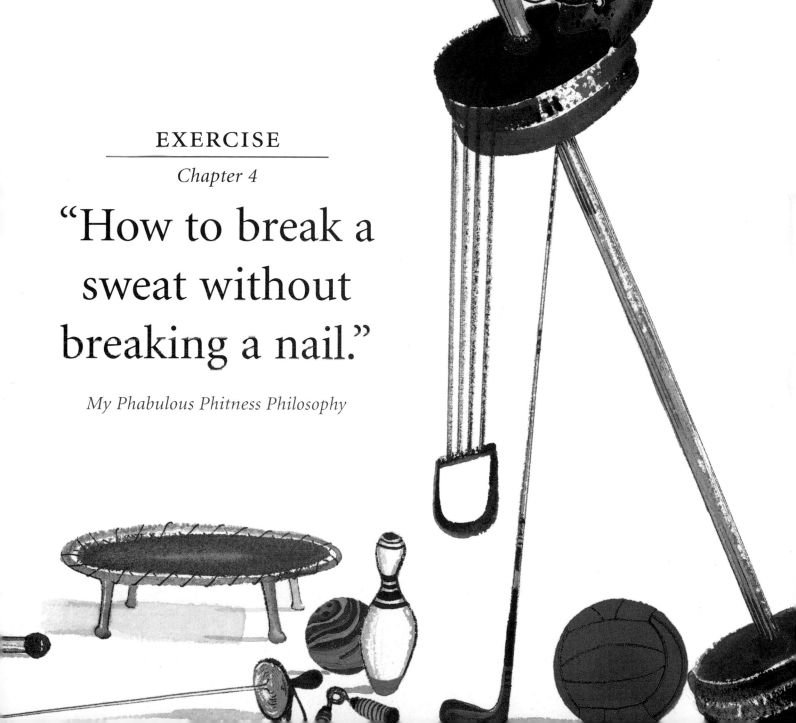

EXERCISE

Chapter 4

"How to break a sweat without breaking a nail."

My Phabulous Phitness Philosophy

Given that I'm a hairy public personality with a hefty pear-shaped figure, I'm often stopped on the street by fans, close-ish friends, and complete lunatics who beg me to reveal my fitness tips.

I credit my vast waistline and trademark mountain of back fat to hour after hour spent as far away from the gym as possible.

Instead, I follow a scientifically unproven exercise regimen that sidesteps the three S's of traditional exercise—sweat, strain, and spandex—while still giving me lots of curves in all the least expected places.

I was painting my nails on the treadmill recently—you know how you do—when I decided to share my phabulous phitness philosophy.

Now, by following my no impact fitness routine, you too, dear reader, can tone up your body without putting down your fork.

MY CATWALK CALORIE COUNTER

How a runway regular pouts away the pounds

1. Walking in a straight line without falling over—minus 1,000 calories

2. Walking left, right, left, right without actually saying "left, right"—minus 350 calories

3. Stealing the limelight from other models—minus 200 calories

4. Loudly complaining about the lack of steaks backstage—minus 200 calories

5. Falling off the catwalk—minus 450 calories

6. Climbing back onto the catwalk—minus 900 calories

7. Calling agent to complain about the lack of steaks backstage—minus 500 calories

8. Cashing hefty checks for two hours work—minus 250 calories

9. Purchasing own steak—minus 150 calories

TOTAL CALORIES LOST WALKING THE CATWALK—4,000

TOTAL CALORIES GAINED FROM WOLFING DOWN STEAK—4,500

WARNING: Stalking the runway is strenuous and dehydrating. Replenish lost fluids with a high-protein vodka and olive concoction before, after, and especially during modeling.

TAKE THE WOBBLE
OUT OF YOUR GOBBLE

Toning Up the Turkey

It has often been said that I have a swanlike neck. Some have even called it swinelike. This is no accident. Each morning, dear reader, I do a simple series of neck exercises that "tone up the turkey."

All you need is a neck weight. I clasp on a $2.5 million Harry Winston diamond necklace, but you can achieve similar results at home by tying a can of extra hearty beef bouillon around your neck with a piece of string. Dietary soups, given their lightness, are not recommended. By following these simple instructions, you too can make your "turkey" as taut and toned as mine.

STEP 1. Tie soup can (or heavy diamond necklace) around your neck.

STEP 2. In a sitting position, look at your neck in a small hand mirror.

STEP 3. Tilt your neck gently upward.

STEP 4. Hold position for 5 seconds.

STEP 5. Gaze in mirror and say, "I have an elegant swanlike neck."

STEP 6. Repeat steps 1 through 5.

STEP 7. Eat soup.

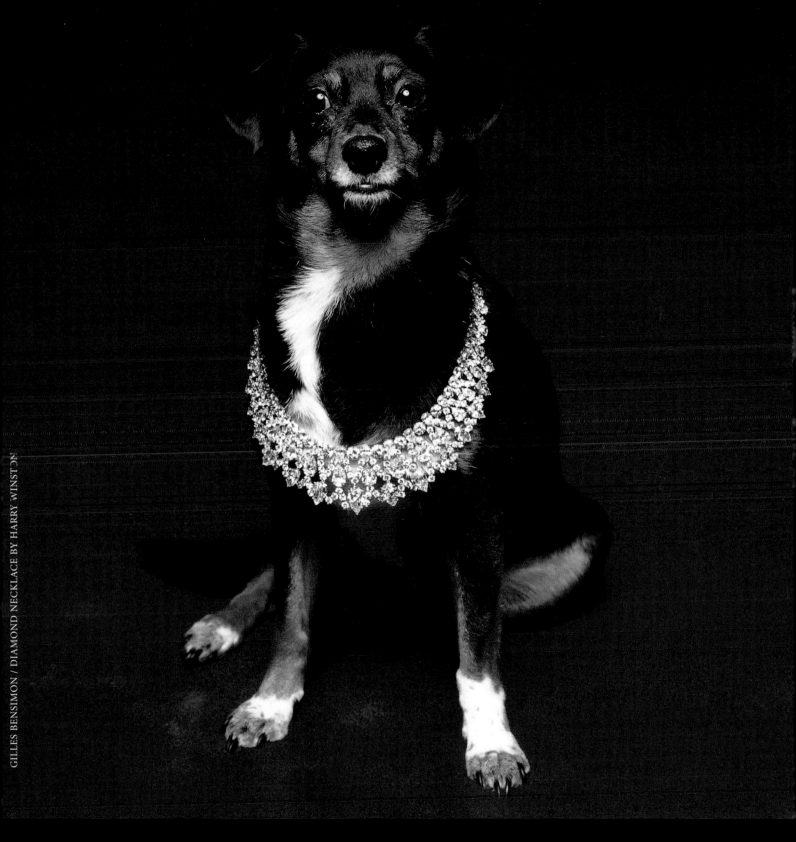

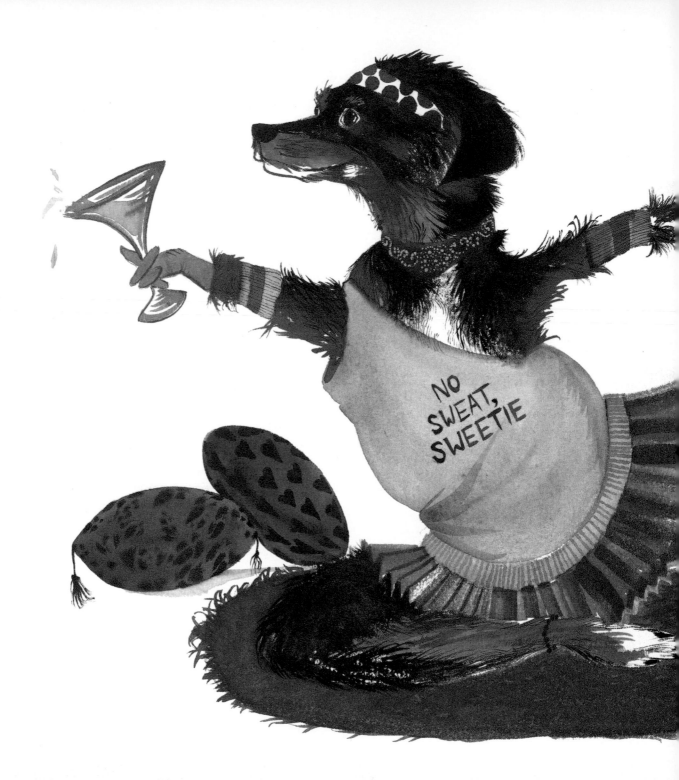

EXERCISE RESTRAINT

*Never lift anything heavier than an
8-ounce cocktail glass.*

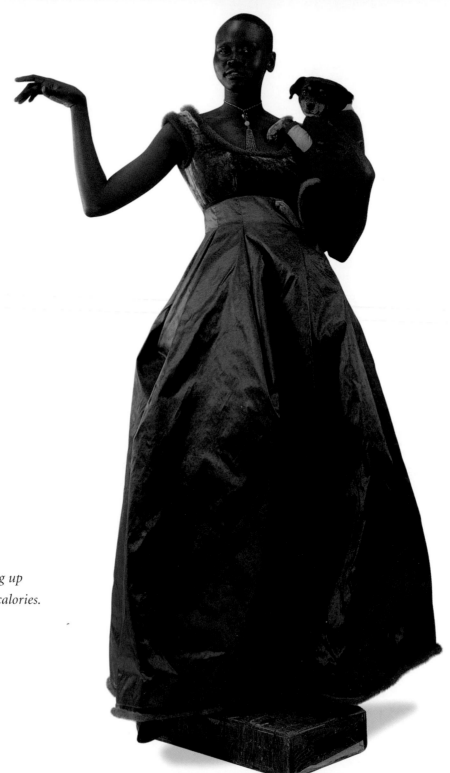

*Me (on the right) burning up
the lens* and *burning up calories.*

READY, SET, MODEL

*A beginner's guide to the ultimate
fat-burning exercise*

During my long-ish career as a top-ish model, I have discovered that posing for photographers is a more effective form of exercise than swimming, hiking, running, and shopping combined!

For instance, trying not to blink while being blinded by flashbulbs is an ideal eye firmer upper. And although staring without expression at a camera is essentially a stationary exercise, it firms up the mouth, cheekbones, forehead, and chewing muscles like nobody's business.

Changing from a blank expression to a smile—the modeling equivalent of going from a jog to a sprint—is not recommended. Not only can this result in serious injury, but a smiling model is as rare as a three-legged Yorkie and even less in demand.

GETTING WAISTED

Turning a beer glass figure into an hourglass figure is a cinch!

If I've said it once, I've said it twice: While conventional exercise may eventually trim your waist from thirty-nine inches to eleven inches, following my patented "fried bacon and no exercise" diet and wearing a corset will get you there a whole lot quicker. In order to tame your wasteland of a waist, you'll need the following items:

1 tight lacing corsetier

100 yards fabric (In the 1880s virtuous women always wore white satin corsets. In your case, dear reader, I recommend lots of color and pattern.)

1 Olympic rowing team to lace you up

1 Olympic weightlifting team (to relieve the rowing team when it takes time out to mop brows and nurse sprains)

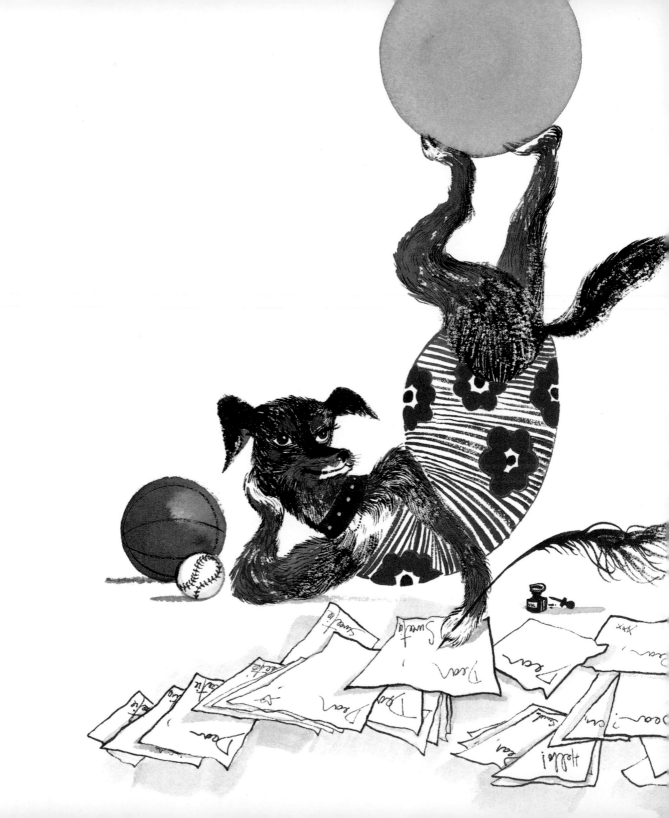

Dear Sweetie,

I could stand to lose a few pounds. What's your feeling on running?

"I only run when I'm being chased."

I have flabby arteries and no amount of exercise firms them up. Any suggestions?

"Wolf down a double portion of deep-fried liver and kidneys. You'll harden up those arteries in no time."

My biggest problem area is weak wrists. This makes it difficult to hail cabs and use swizzle sticks. Heeeelp!

"Try lifting a martini (served in a fish bowl) to your lips at regular intervals. Add olives at your own pace."

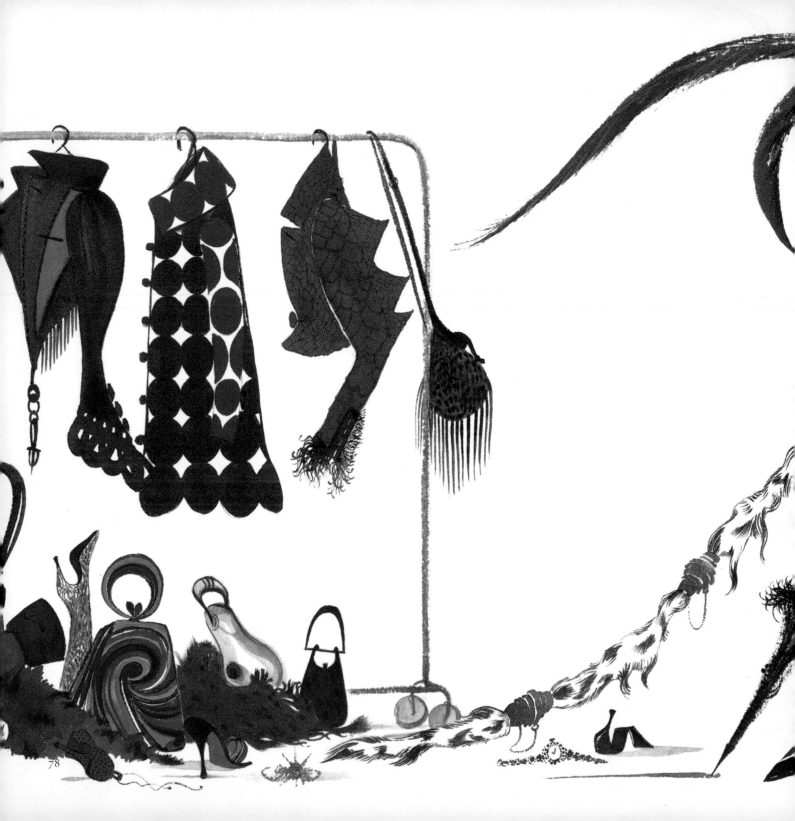

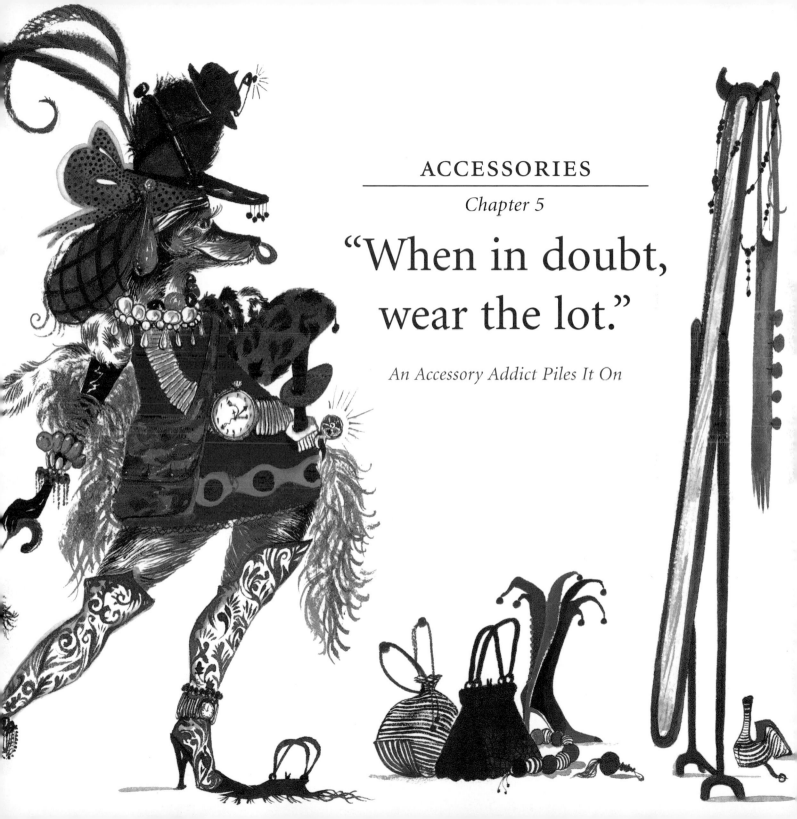

ACCESSORIES

Chapter 5

"When in doubt, wear the lot."

An Accessory Addict Piles It On

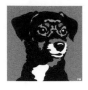

Lesser style icons than me believe that you should always remove one piece of jewelry before you leave the house.

This is what makes them lesser.

I wore a ruby, a diamond tiara, and a triple strand of pearls in my belly button recently—you know how you do—and every eye at the supermarket was riveted on my hairy midriff. The function of accessories is to draw even more attention to your many lovely features. For example, if I didn't drape myself in a barrow full of bangles, beads and baubles, my floppy ears, swinelike neck, and hairy wrists might actually go unnoticed!

Adopt my "more is still not enough" philosophy and avoid becoming an accessory to that most unthinkable of fashion crimes—subtlety.

HIGH HEELS AND HAIRY LEGS

Selling your sole for shoes

If you're anything like me, dear reader—and let's face it, if I shaved my legs and waxed my midriff we could pass as twins—you'd sell your sole for a stiletto. Go ahead and make a date with the Devil. After all, what's an eternity spent in the toasty flames of hell compared to a seductive sandal, spike, or slipper?

Sauceress

the Hello Sailor

CHAPEAUS THAT CATCH BEAUS

How to snare a fella with a fedora or a fez

One of the most effective ways to catch a collie, a Chihuahua, or a compliment is to enhance your natural beauty with a jauntily worn chapeau. Whether it's a pillbox or a cardboard box, a hat not only frames your face but also disguises potential turnoffs like baldness.

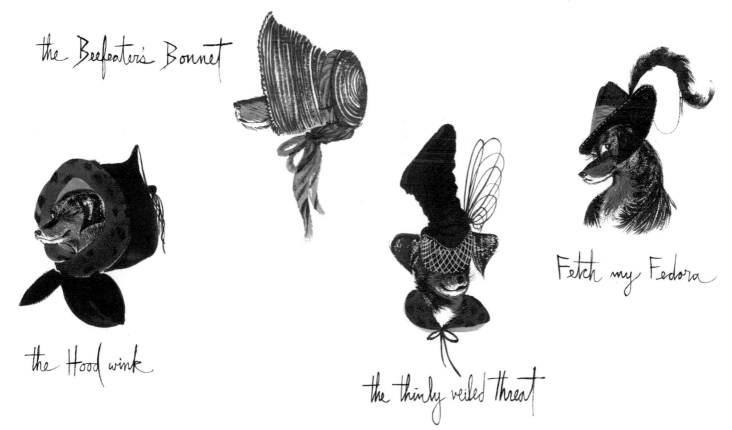

the Beefeater's Bonnet

the Hood wink

the thinly veiled threat

Fetch my Fedora

SHOULD YOUR BAG ALWAYS MATCH YOUR BACK FAT?

An open-and-shut case

As the world's leading authority on purses, I'm often called upon to lecture at clutch bag symposiums and suitcase summit meetings. Follow my handy handbag hints and keep purses in proportion.

HANDY HANDBAG HINTS

1. Hefty girls should carry picnic hampers.

2. Really hefty girls should flatter their frames by carrying a suitcase or a trunk.

3. Thin girls—annoying as they are—look best with slender clutches.

4. Backpacks are the perfect-size bag to use when shoplifting turkeys.

5. An evening bag should be big enough to carry an acceptance speech and a steak.

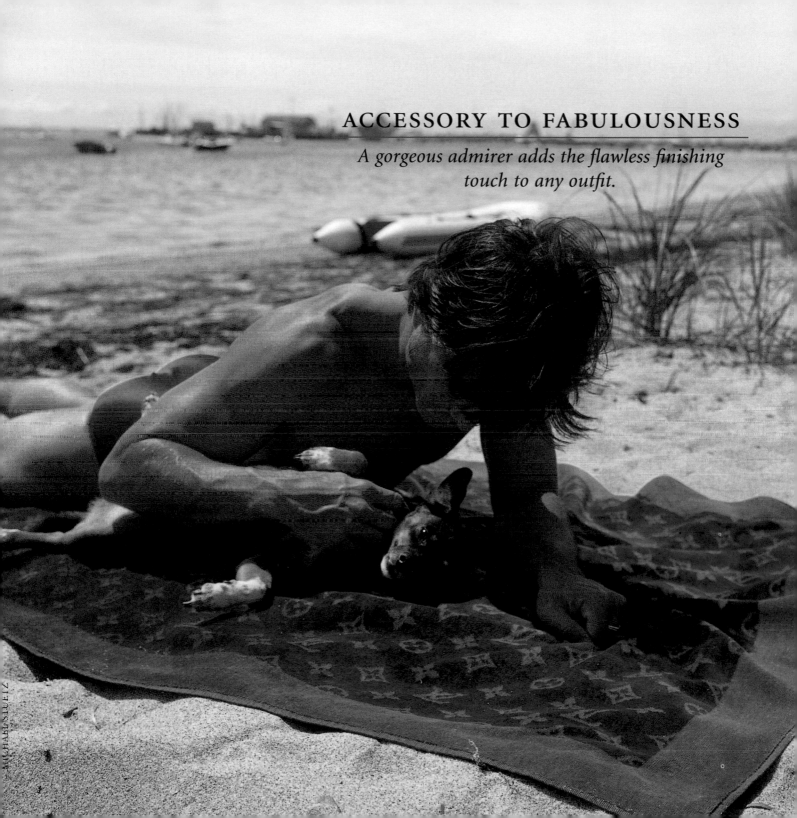

ACCESSORY TO FABULOUSNESS

A gorgeous admirer adds the flawless finishing touch to any outfit.

4. Rubies are the perfect

I LIKE MY RUBIES LIKE MY MEAT—
RED AND VERY RARE

Matching your rocks to your roast beef

Long before I became aware of the importance of matching jewelry to food I made the unforgivable faux pas of wearing sapphires while eating lobster. As a result I was stricken from the international best-dressed list and informed in the strongest possible terms that "blue jewels clash horribly with orange food." Don't make my mistake, dear reader. Always coordinate what's around your neck with what's on your plate.

AS A RULE:

1. Canary yellow diamonds should be worn when eating yellow canaries.

2. Baguette diamonds go well with baguette loaves.

3. A triple strand of black pearls is always correct with caviar.

compliment for anything that moos.

5. Due to a lack of blue foods, sapphires should not be worn at the table.

A word of caution: Matching emeralds to salad is as dangerous as eating salad itself.

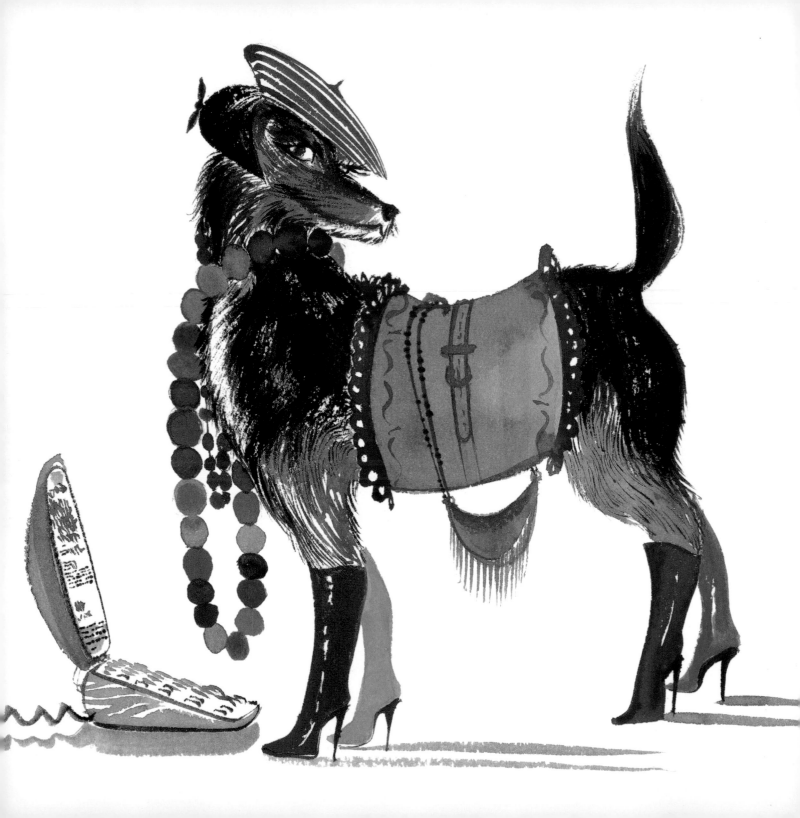

Can I wear jangly bracelets to the office?

"Absolutely! I'm a huge fan of noisy jewelry.
It alerts my fans that I'm approaching."

Are there still occasions when it's appropriate to wear elbow-length gloves?

"Elbow-length gloves are perfect for picking locks to
butcher shops. Pocket a pork chop without leaving a
paw print!"

Where do you stand on wearing sunglasses at night?

"Sunglasses help the paparazzi differentiate major
celebrities (i.e., me) from normal people (i.e., you).
Ordinary folk may wear sunglasses after nightfall
under the following circumstances: to hide pinkeye,
a black eye, or crossed eyes."

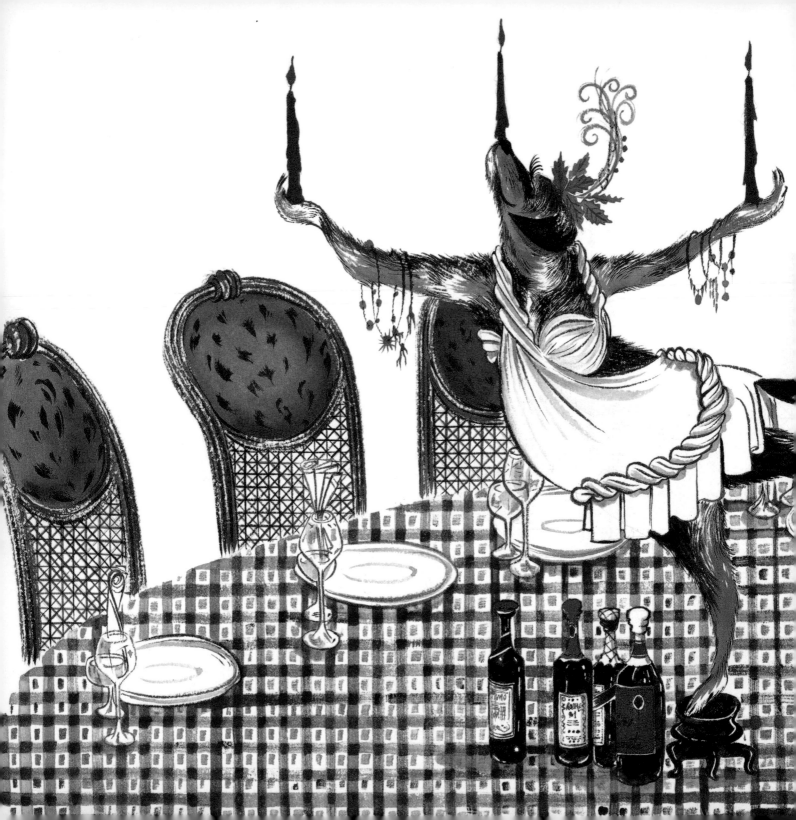

Chapter 6

"Entrails at eight. Don't be late."

*Entertaining Insights from a
Hairy Hostess*

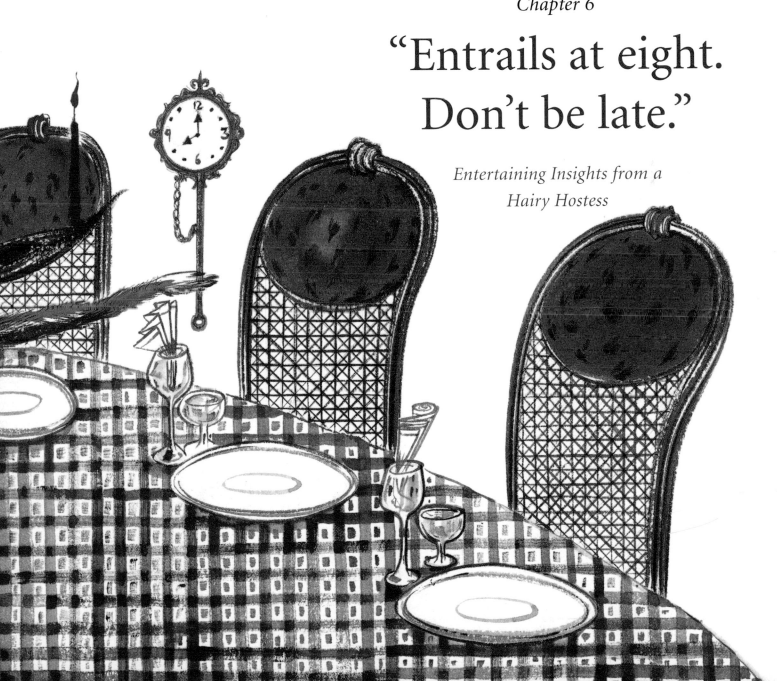

I'm the first to admit, dear reader, that my blood is less blue than it is an undistinguished muddy brown.

As a child, I used to wipe my mouth with my paw and scratch my armpits with a salad fork. But now, like many a mutt before me,

I've risen above my bleak beginnings.

I've learned that one should always compliment the hostess on her lustrous chest hair and that the initials RSVP actually stand for "Receive Sausages Very Politely." I used to play with an empty can of hairspray pretending that it was a full can of foie gras—you know how you do—but now that I'm a scintillating socialite I prefer to play pin the tail on the poodle.

Follow my guide to social success and put the *grrr* back into gracious entertaining.

I'M FABULOUS,
YOU'RE FABULOUS.

How a continental carnivore meets and greets

It's a little known fact that I personally invented the international symbol for fabulousness—the air kiss.

While a handshake or a hug remain popular forms of greeting, continental carnivores and furry fashionistas prefer to demonstrate their affection by kissing without touching. This not only protects against smeared lipstick and rumpled gowns but also allows the embracer to continue talking without pausing to pucker. Take my leash, I mean lead, and put a little chic into your next brush with a cheek.

WEARING CAPES WITH THE CALF'S LIVER AND FISHNETS WITH THE FILET

The lost art of changing clothes between courses

Perhaps the greatest advantage of entertaining at home is that I can change ensembles between the calf's liver entree and the flambéed filet dessert. This not only enables me to spill soup on my skirt without a care in the world but also provides my guests with more than one opportunity to compliment me on my outfit.

At your next dazzling dinner, try slipping into something more comfortable between courses.

1. Elicit applause by coordinating exotic appetizers with kimonos and capes.

2. Cause a stir by slipping into a ball gown made entirely of live goats when serving meaty main courses.

3. For a fitting finale, give your adoring audience their just deserts by pulling on a pair of flammable fishnets. Just light and serve!

COURTESY OF ANIMAL FAIR MAGAZINE

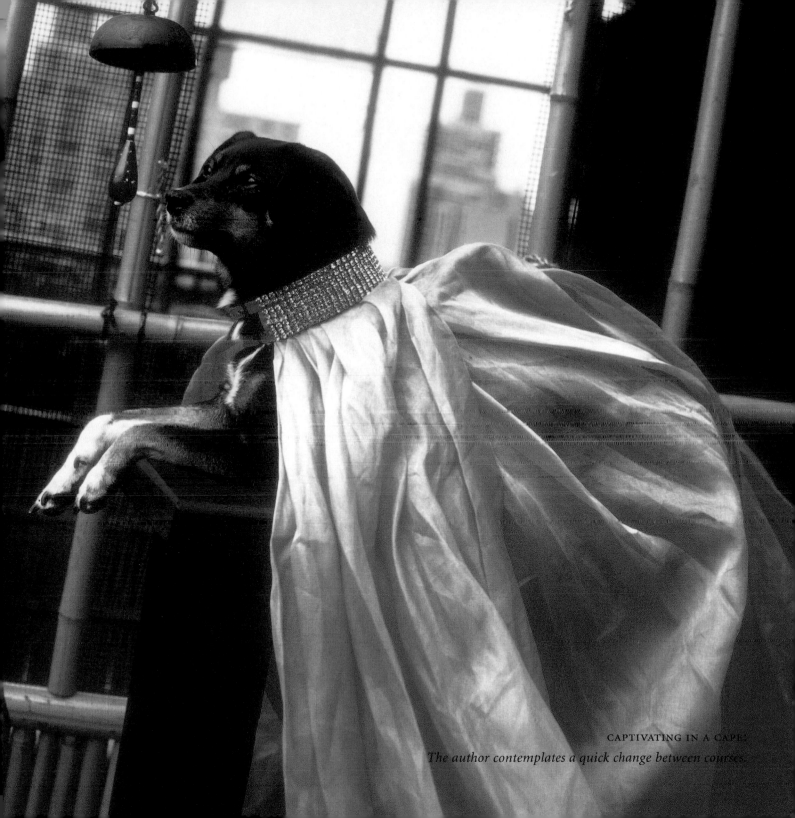

CAPTIVATING IN A CAPE:
The author contemplates a quick change between courses.

5. Remember, never

ALWAYS TALK WITH YOUR MOUTH FULL

A Manhattan mutt's guide to blue blood behavior

During my meteoric ascent from squalor to social superstardom, I've learned how to pluck my eyebrows with a nutcracker and how to tango on a tabletop without spilling my drink. Now you too can polish your rough edges by following my politeness pointers.

A PROPER POOCH'S POLITENESS POINTERS:

1. Don't throw cigarettes in the toilet as it makes them soggy and difficult to light.

2. A basket of freeze-dried pork bellies always makes the perfect hostess gift.

3. Fill awkward gaps in conversation by reciting the alphabet.

4. The correct way to receive a compliment is to enthusiastically agree.

5. *push a lady while she's shaving.*

6. Stealing from your host's medicine cabinet is the ideal way to replenish your own.

7. Always remove your shoes when dancing on the table in between courses.

8. Achieve perfect posture by walking with a roast beef on your head.

GUESS WHO'S COMING TO DINNER

Seating the quail quiche next to the Chicken à la Sweetie

In my extensive experience as a hostess, I've found that the best dinner companions are the ones you can eat. Why indulge in conversation with a half-baked (not to mention half-crocked) guest when you can sink your teeth into a mute meat pie or a speechless sausage? Use my dream dinner date seating plan to construct your own edible guest list.

HAIRY HOSTESS

PIG TROTTER PUREE

ROADKILL RATATOUILLE

SQUIRREL SURPRISE

GOAT GIZZARD GOULASH

BEEFY BOMB ALASKA

RECIPE FOR DISASTER

What's wrong with this picture?

The scene is set. The wine is chilled. The hostess is
lovely as ever. At first glance, dear reader, everything is
in place for yet another legendary lunch
Chez Sweetie. So what's wrong with this picture?
Turn the page upside down to find the faux pas.

(ANSWER) Where are the wieners? Considerate carnivores
never serve sausage-loving socialites fruit.

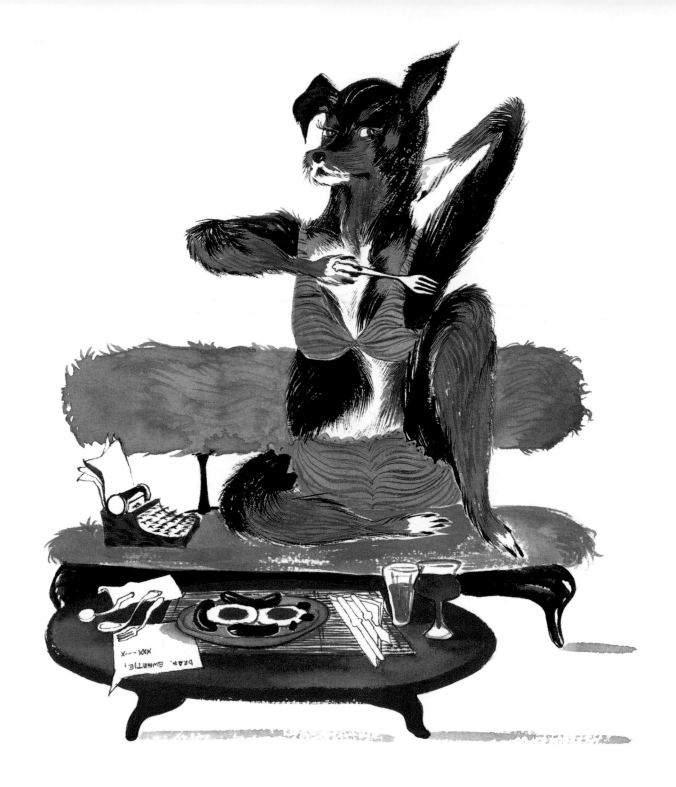

Dear Sweetie,

I accidentally smashed a crystal goblet at a dinner party recently. Should I have offered to pay for it?

"On those frequent occasions when I smash a host's crystal, I feign a glass splinter and threaten a lawsuit. Negotiate a soup tureen, the family pet, and a sofa as settlement."

If a hostess invites me to dinner at 8 P.M., what's the correct time to arrive?

"An 8 P.M. invitation indicates that your hostess is planning to make her grand entrance at approximately 8:10 P.M. You should make an even more elaborate entrance (think footmen and carriages) no later than 8:11 P.M."

I'm so intimidated by the array of cutlery at formal dinners that I prefer not to eat at all. What do you do if you don't know a soup spoon from a demitasse spoon?

"Inform your hostess that you used to be an Ethiopian princess in an earlier life and eat with your paws."

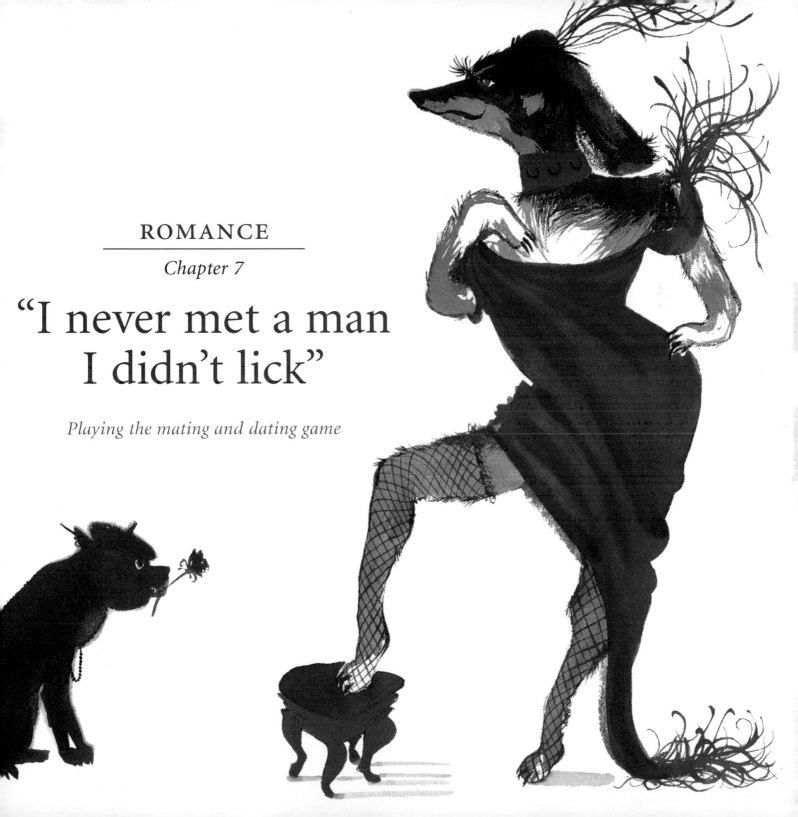

"I never met a man I didn't lick"

Playing the mating and dating game

I'm the first to admit, dear reader, that

I'm an irresistible man magnet.

Ever since I was an innocent young pup wearing
chicken bone earrings and loitering outside the local butcher,
boys of all breeds have showered me with steaks and
tried to lure me down the garden path. They're only human-ish.
At the precocious age of two I drenched myself in a fragrance
made of roast beef and gravy—you know how you do—and had men
lining up for hours just to sniff me.

To what do I owe my incredible success with the hairier sex I hear you ask?

The answer is simple. I follow a scientifically unproven
array of ploys, tricks and man-eating manipulations that
turn even the toughest dogs into pussycats.
Follow my highly effective "romantic rules" and
you too will have men sitting at your
feet, rolling over and begging for more.

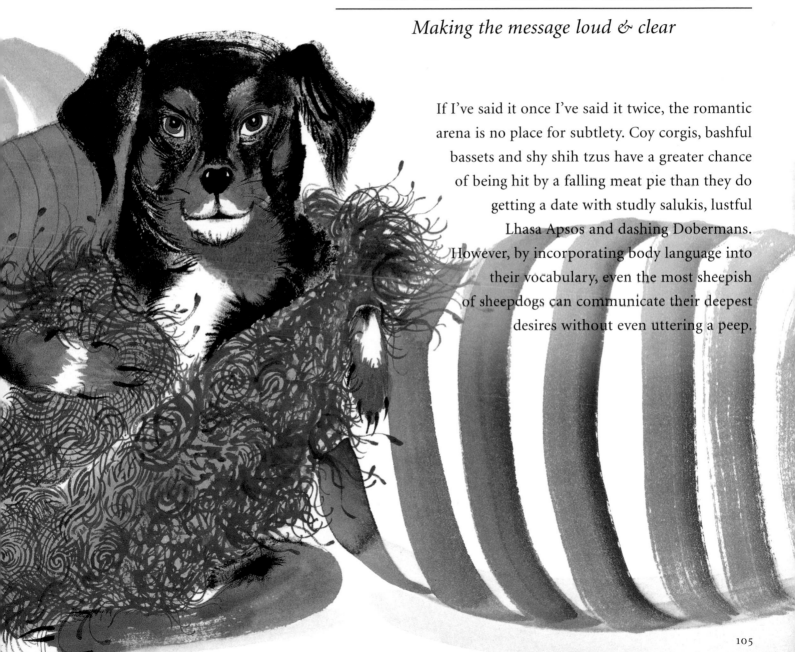

DOES YOUR BODY LANGUAGE HAVE THE RIGHT ACCENT?

Making the message loud & clear

If I've said it once I've said it twice, the romantic arena is no place for subtlety. Coy corgis, bashful bassets and shy shih tzus have a greater chance of being hit by a falling meat pie than they do getting a date with studly salukis, lustful Lhasa Apsos and dashing Dobermans. However, by incorporating body language into their vocabulary, even the most sheepish of sheepdogs can communicate their deepest desires without even uttering a peep.

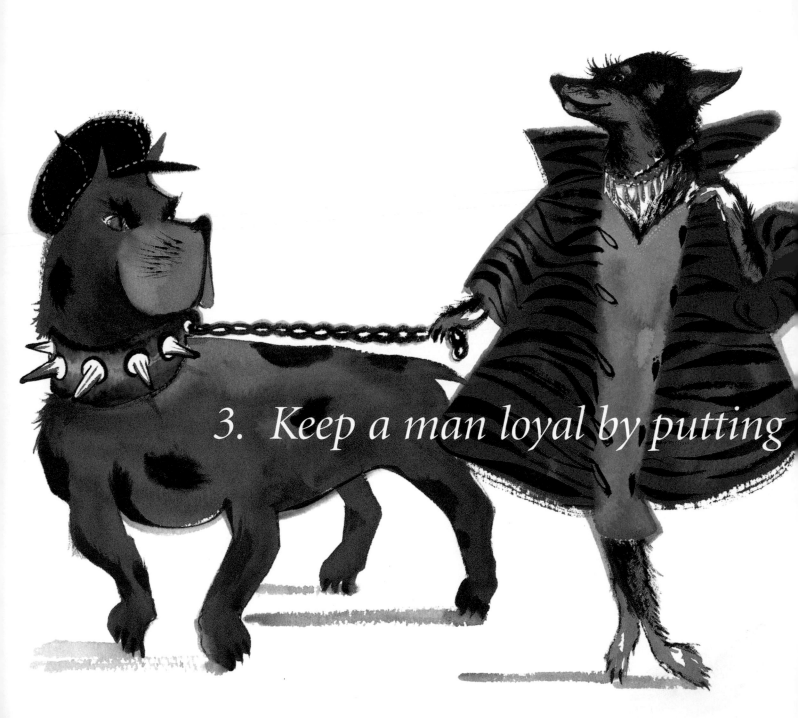

3. Keep a man loyal by putting

MEN ARE DOGS,
WOMEN ARE BITCHES

Lessons learned from a life of l'amour

As the internationally acknowledged darling of the dog run I know a thing or two about what makes men growl, whimper, and yelp. Save yourself time and learn from my vast experience, dear reader. After all, it'll take you a dog's age to learn from your own.

A FURRY FLOOZY'S LESSONS LEARNED

1. Men will say anything to get into your kennel.

2. Lie down with dogs and you'll wake up with puppies.

him on a very short leash.

4. The sign of true love is waking up and finding bacon under your pillow.

5. A broken heart is best mended by breaking the offending party's legs.

6. Keep a man keen by treating him mean.

7. If you like your earlobes nibbled, wear earrings made of rare filet.

8. Candlelight is flattering but no light is even more so.

9. Small dogs are nothing more than wolves in Chihuahua's clothing.

10. The best way to get over a dog is to get under another one.

"Remember girls,
Men make passes
at girls
with big
es!"

GETTING PERSONAL

Why it pays to advertise, advertise, advertise.

During those rare times that I find myself without a man I advertise my availability to potential escort-bodyguards through the personal ads.

Do what any girl in heat would do, dear reader, and use my hugely effective personal ad as a model for your own.

LOVE OF MY LIFE #186

Atticus

BREED: Golden retriever

FAVORITE COLOR: Blonde

FAVORITE PASTTIME: Touching up his roots

SECOND FAVORITE PASTTIME: Accompanying famous style icons to public appearances in butcher shops

OCCUPATION: Muse for hair colorists

MOST CHERISHED POSSESSION: His blow-dryer

KNOWN FOR: His devotion to balls, bleach, and famous style icons

LENGTH OF RELATIONSHIP: The dog days of summer

REASON FOR BREAKUP: His devotion to balls and bleach outweighed his devotion to a certain famous style icon

LESSON LEARNED: Never date anyone with better hair than your own

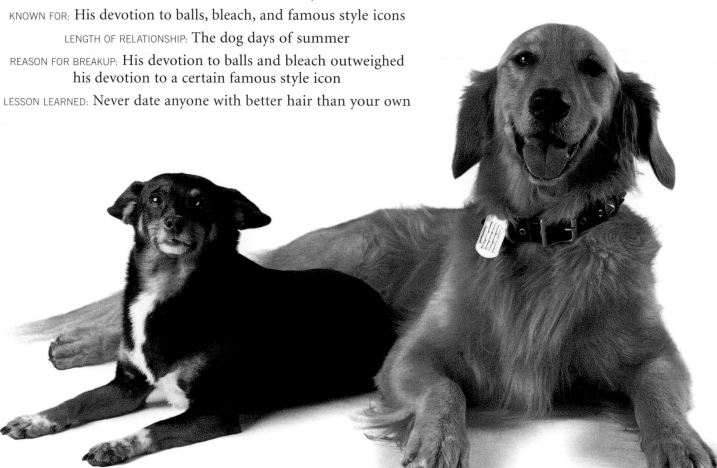

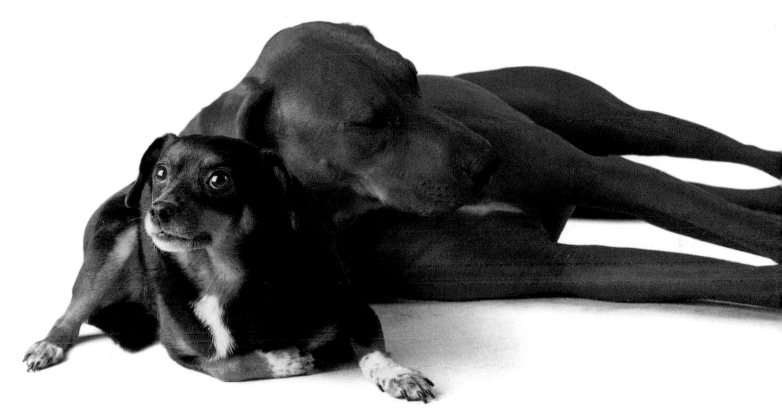

LOVE OF MY LIFE #78

Rex

BREED: Rhodesian Ridgeback

PECULIAR PHYSICAL TRAITS: Missing a ridge

GREATEST DESIRE: To get his ridge back

OCCUPATION: Freelance stud

FAVORITE PASTTIME: Admiring his reflection in moonlit ponds

HE BEGINS MOST SENTENCES WITH: "Have you ever seen such a handsome face?"

HE ENDS MOST SENTENCES WITHOUT: Making a point

LENGTH OF RELATIONSHIP: Lunch

LESSON LEARNED: Never date anyone prettier than you

LOVE OF MY LIFE #348

Liberace

BREED: Norwich terrier

HEIGHT: 10 inches (but acts like he's 17 inches)

PERSONALITY TYPE: Napoleonic

MY NICKNAME FOR HIM: "The Apricot Terrorist"

HIS NICKNAME FOR ME: "The loveliest woman ever born"

HIS MOST MEMORABLE GIFT TO ME: Fleas

MY MOST MEMORABLE GIFT TO HIM: Ticks

HIS MAIN MISSION IN LIFE: To mount a famous style icon.

HE BEGAN MOST SENTENCES WITH: "If I only had a ladder…"

HE ENDED MOST SENTENCES WITH: A frustrated sigh

LENGTH OF RELATIONSHIP: Appropriately brief

LESSON LEARNED: Never date anyone who gets on your back

LOVE OF MY LIFE #439

Wink

BREED: Decidedly mixed

OUR FIRST DATE WAS: Behind the neighbor's garbage bins

OUR FIRST MEAL WAS: The contents of the neighbor's garbage bins

THE FIRST GIFT HE GAVE ME WAS: A breath mint

OUR SHARED INTERESTS INCLUDE: Searching for our roots

ALLERGIC TO: Teacup poodles

HE CALLS ME: "A magnificent mutt"

I CALL HIM: Right

FAVORITE SAYING: "If I had a dime for every time someone said I looked like a Doberman, border collie, corgi, German shepherd mix I'd have a dime."

LENGTH OF RELATIONSHIP: Six months and counting

LESSON LEARNED: Mutts rule!

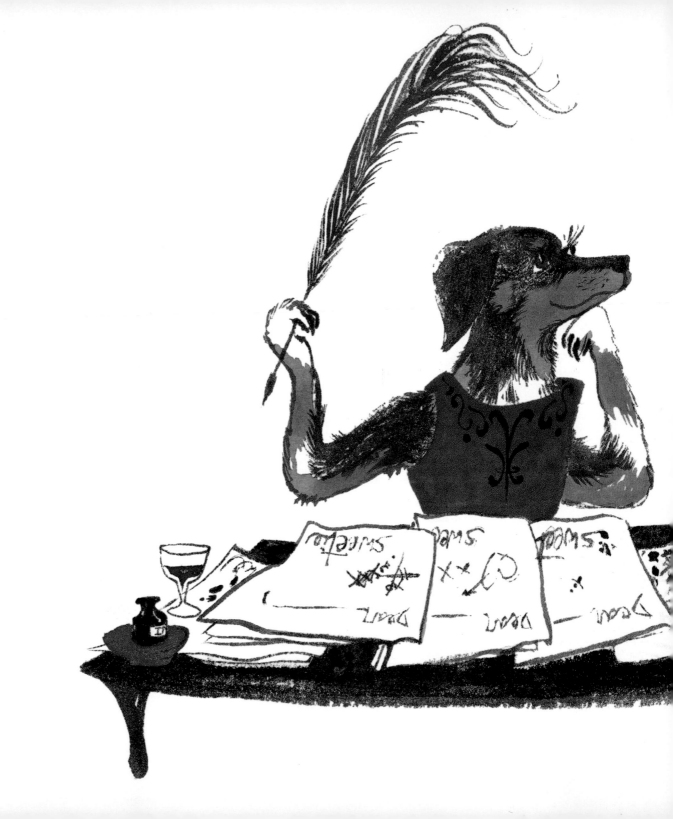

Dear Sweetie,

*I read about you being out on the town with a
different dog every night of the week. Are you attracted to
all men or do you have a specific type?*

"My type of man is hairy with really bad breath."

Do you believe in the old-fashioned notion of love at first sight?

"Absolutely. The first time I laid eyes on a fatted calf,
I knew we were meant for each other."

*My new boyfriend is all over me like white on rice, but
most of the time all I want to do is kick off my shoes
and paw through your fabulous book. What should I do
if he's in the mood and I'm not?*

"Roll over and play dead."

"Yes, I am an international woman of mystery."

Wandering All Over the Map with the Eighth Wonder of the World

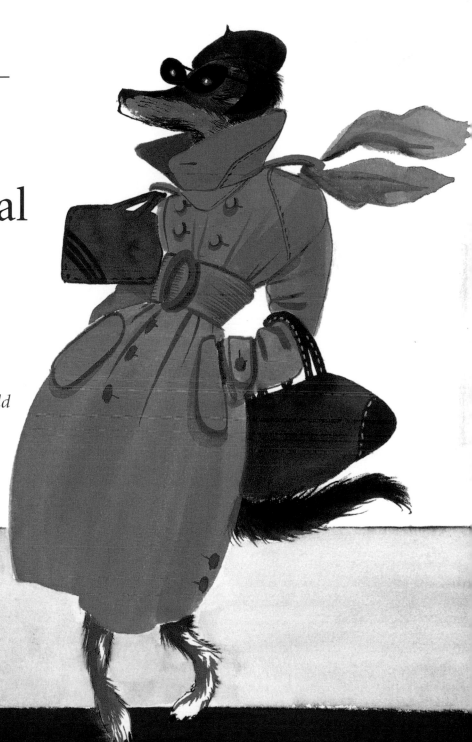

One of the drawbacks of being a roving fashion ambassador and international incident waiting to happen is that I'm frequently recognized by starstruck customs officials. "Sweetie," they say, admiring my gorgeous luggage and matching porter, "do you have anything to declare?"

"I have nothing to declare but my ravishing beauty,"
I reply, conveniently forgetting to mention the case of scotch tucked away in my suitcase of silks, satins, and sausages.

This ability to lie in one or more languages is just one of the marks of a truly sophisticated traveler, dear reader. Follow my itinerary and

soon you too will be able to glide about the globe without so much as a hiccup or a belch.

TURNING FRANCS INTO FRANKFURTERS

Exchange rates you can eat

How much beef can you get for your buck in Biarritz?
How much prosciutto can you purchase for a pound?
Follow my foreign currency exchange guide, dear reader,
and turn mad money into meat.

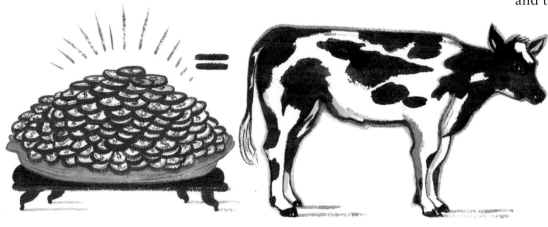

MY CASH FOR COW CONVERSION CHART

One German mark = 3 ounces of wiener schnitzel

Three Dutch gulden = four slices of bratwurst (thin)

Five French francs = a spoonful of boeuf bourguignonne

Ten yen = a sniff of soy sauce

A thousand lire = not so much as a moo

NEXT STOP, FABULOUSVILLE

A plugged-in pooch's guide to globetrotting with glamour

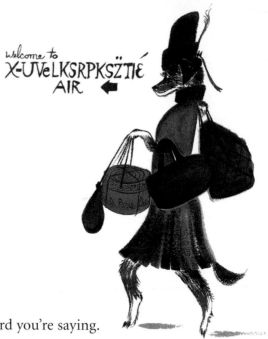

Given that I'm a glamorous gadabout and furry frequent flyer, I know a thing or two about how to make a foreign foray fabulous. Take a pointer from a plugged-in pooch and follow my dos and don'ts.

DON'T fly on airlines with names you can't pronounce.

DO speak foreign languages without understanding a word you're saying.

DON'T wear wigs in hotel pools. They get sucked into the filter and clog the drain.

DO fill empty bottles of vodka with water and replace them in the mini bar.

DON'T speak to fellow passengers unless they offer you their steak.

DO pack furs for island vacations. There may be a tropical storm.

DON'T eat anything navy blue.

DO place slices of salami on nipples to avoid topless bathing sunburn accidents.

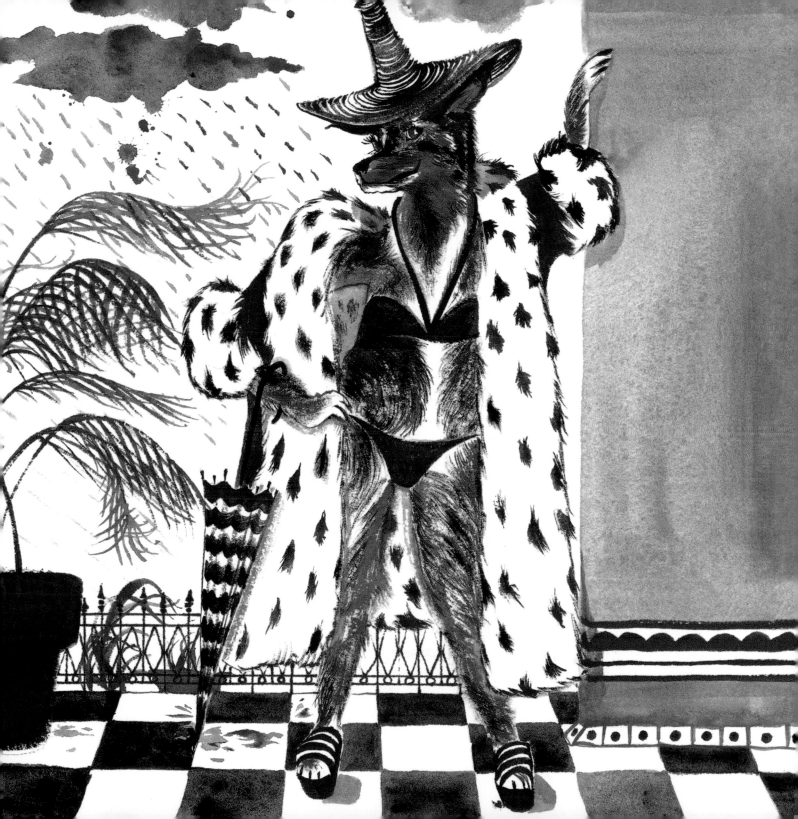

PLUGGED-IN POOCH'S
POINTER #261

Wear a G-string at all times.
It's the perfect excuse for never carrying cash.

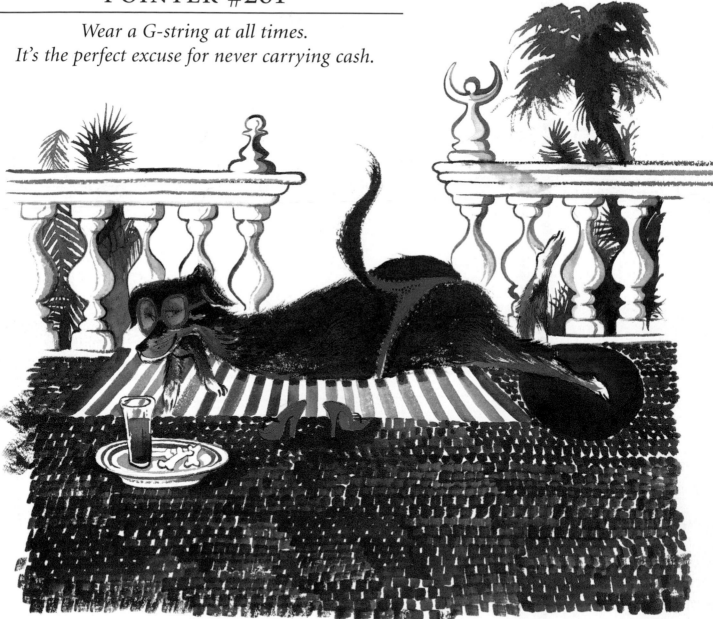

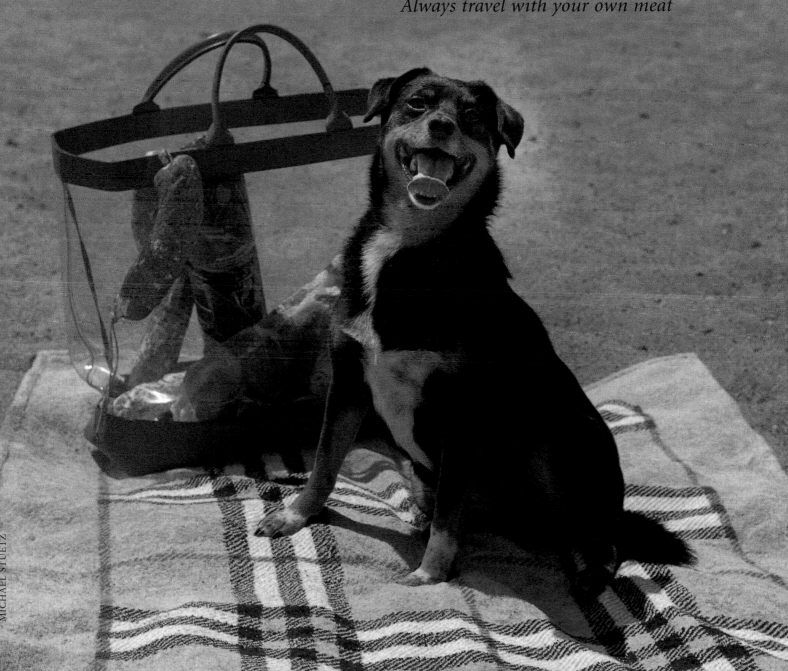

PLUGGED-IN POOCH'S
POINTER #39

Always travel with your own meat

MICHAEL STUETZ

A SECOND-CLASS
RIDE IS BETTER THAN A
FIRST-CLASS WALK

Covering ground without touching the ground

People are forever trying to take me on a walk, dear reader.
Don't they know I prefer to ride? By making it a policy to never
travel by foot, I arrive faster and fresher by far.
Take some advice from a hairy high
flyer and give walking a good swift boot!

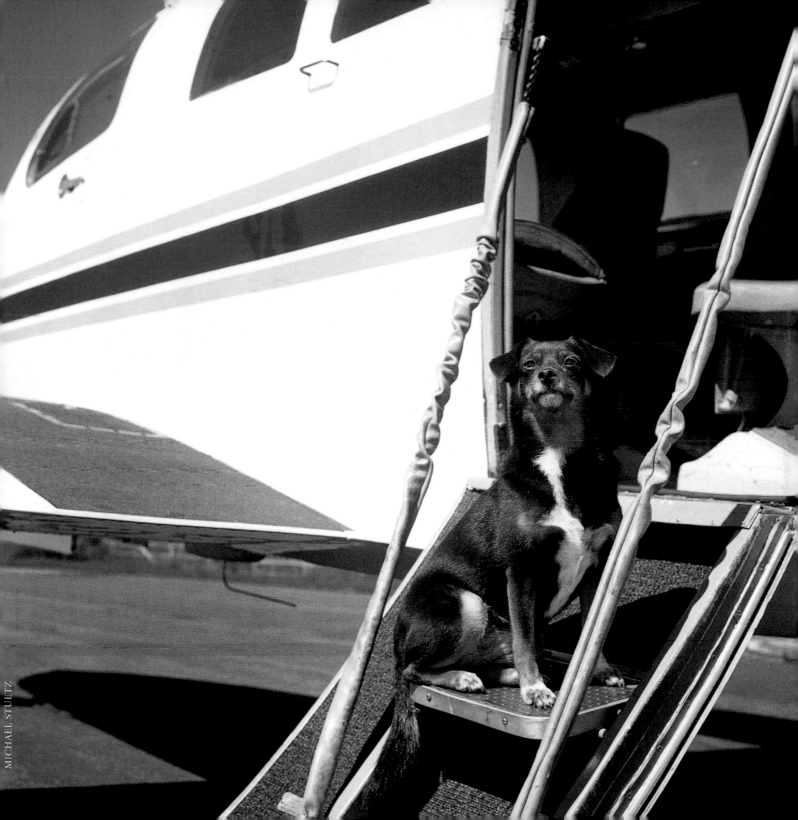

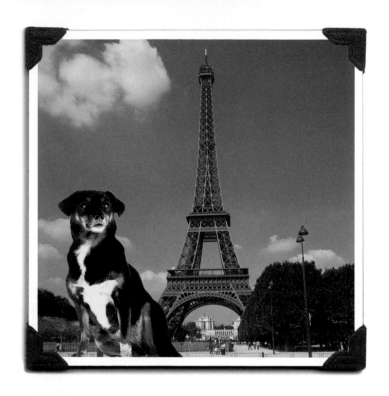
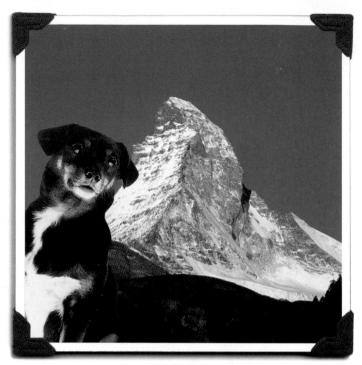
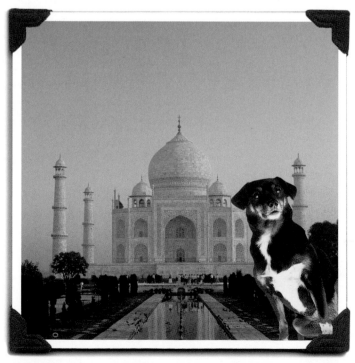
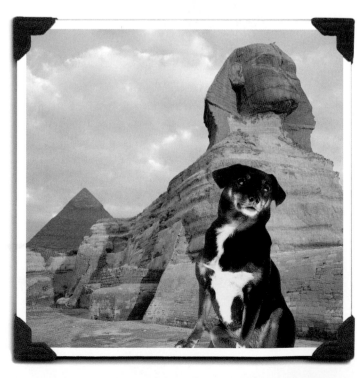

JET SETTING WITHOUT THE JET LAG

How to see the sights without leaving the house

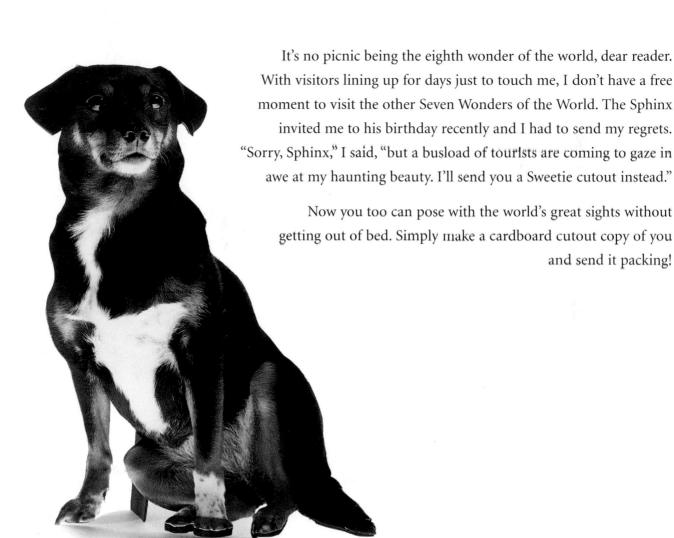

It's no picnic being the eighth wonder of the world, dear reader. With visitors lining up for days just to touch me, I don't have a free moment to visit the other Seven Wonders of the World. The Sphinx invited me to his birthday recently and I had to send my regrets. "Sorry, Sphinx," I said, "but a busload of tourists are coming to gaze in awe at my haunting beauty. I'll send you a Sweetie cutout instead."

Now you too can pose with the world's great sights without getting out of bed. Simply make a cardboard cutout copy of you and send it packing!

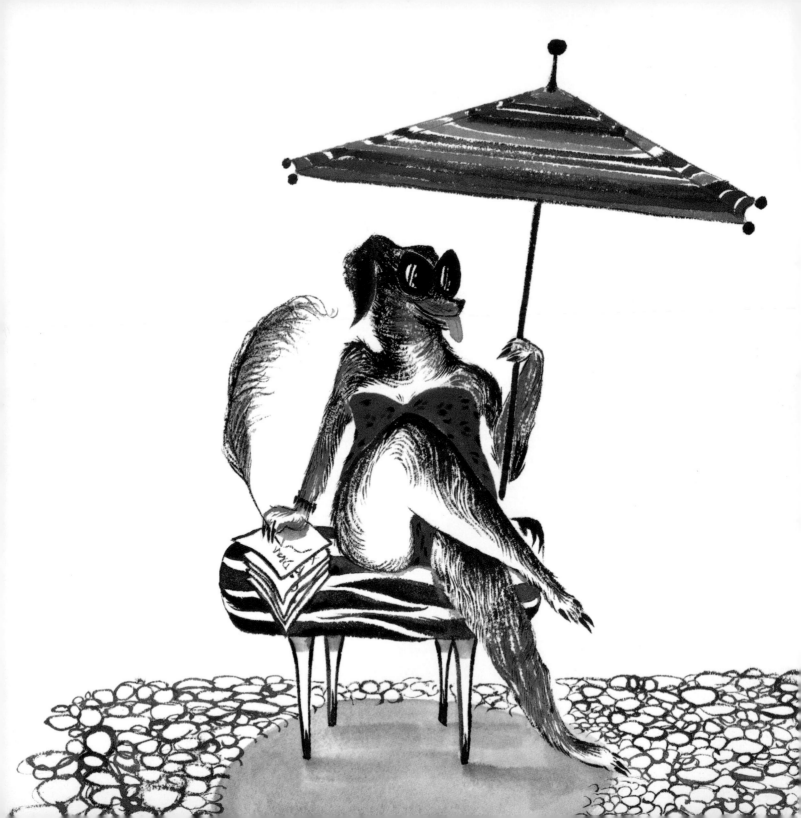

Dear Sweetie,

I was in Miami recently and all the girls were wearing thongs. I'm daring but not that daring. Any swimsuit suggestions?

"Do like me and stand out from the thonged throng by wearing a fur-kini!"

I'm thinking of inviting someone on an all-expenses-paid tour of Italy's prosciutto factories. What do you look for in a travel companion?

"Someone who'll invite me on an all-expenses-paid tour of Italy's prosciutto factories."

What should I pack for a two-week Mediterranean cruise?

"Things that begins with "S." Start with sausages, salami, steak, and stilettos. Oh, and don't forget the sunscreen."

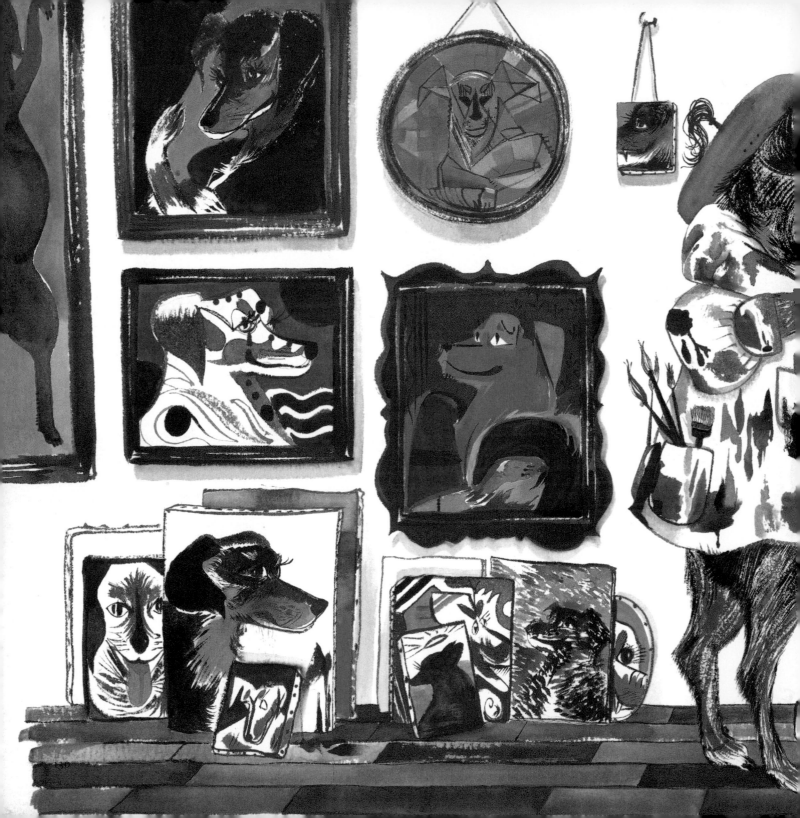

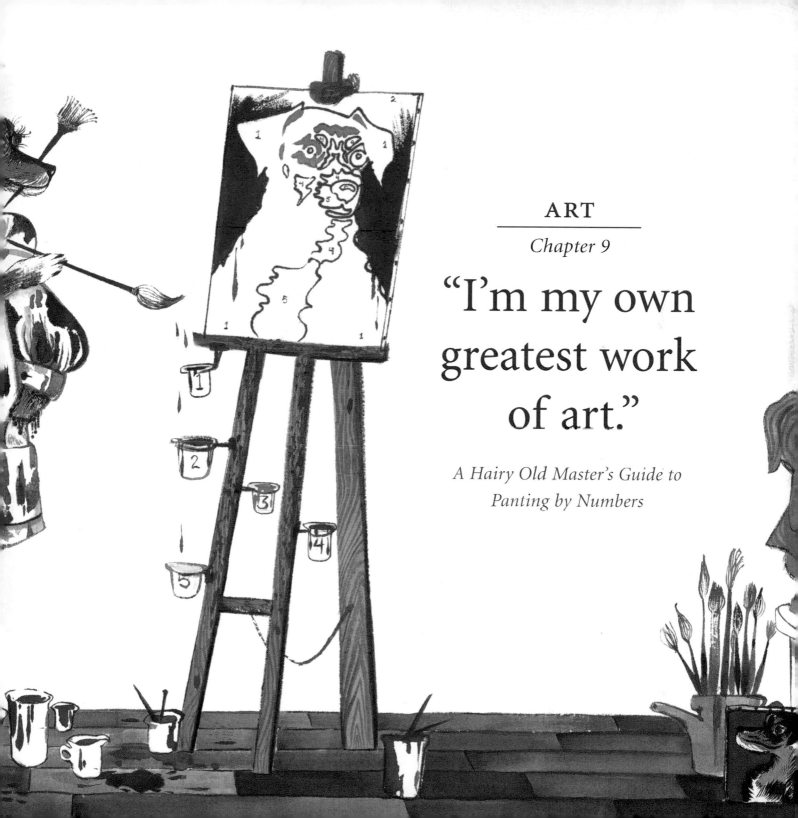

ART

Chapter 9

"I'm my own greatest work of art."

A Hairy Old Master's Guide to Panting by Numbers

I began life in an uncultured backwater town where a horseshoe tacked over a doorway constituted a major artistic statement. But then show me a major artist who didn't.

When I was barely three years old I created a series of paw prints out of mud and a threadbare bath towel.

Not surprisingly, these now overshadow the Mona Lisa as the main attraction at the Louvre. At a recent gallery opening, a collector asked me the question on everyone's lips. "You're a major figure in the art world," she said, admiring my major figure. "Do you think those mice dipped in wax are really worth $350,000?" "Call me a hairy philistine," I replied, grabbing a glass of wine and a wheel of Brie, "but in my book (and this is my book)

if you can't frame it or eat it then you can't call it art."

BEWARE! AVANT-GUARD DOG

Unleashing the performance artist within

I do an act with a wedding dress and a ham that brings the house down every time. I'm a performance artist, you see, and therefore skilled at making elaborate artistic statements with tulle and meat. Performance art is quite possibly the best panacea for boredom. Just when you think you've seen it all, there I am hanging upside down from a butcher's hook, wearing a tattered wedding dress, clutching a ham, and reciting the alphabet backward.

TO BE A PERFORMANCE ARTIST, YOU WILL NEED A SELECTION OF THE FOLLOWING:

1. Talent (optional)

2. A television set (worn as a headdress)

3. An audience (optional)

4. Last season's shoes (worn as gloves)

5. A monotonous soundtrack (think chanting monks, dripping water, German opera)

6. A nude-colored body stocking made of stitched together slices of baloney.

7. A flammable nightie and a box of matches

8. A first-aid kit

9. An endless capacity for boredom

10. A real job

NOW THAT'S A FACE
WORTH FRAMING!

Turning a blank expression into
an abstract expression

Take it from one who knows, dear reader, the dullest (not to mention chilliest) profession in all the art world is that of the nude artist's model. I was modeling au natural in a freezing Paris garret—you know how you do—when I devised a way to break the boredom. Much to the entertainment of the class, I contorted my face into a series of abstract expressions. Little did I know that my talent for pulling faces would give birth to the art movement known as abstract expressionism. By following my famous face, you too can become a devotee of the Sweetie School of Really Abstract Expressions.

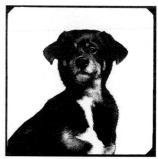

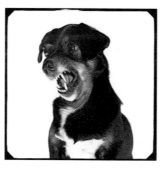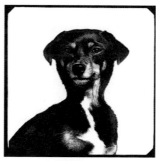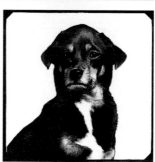

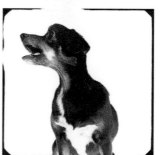

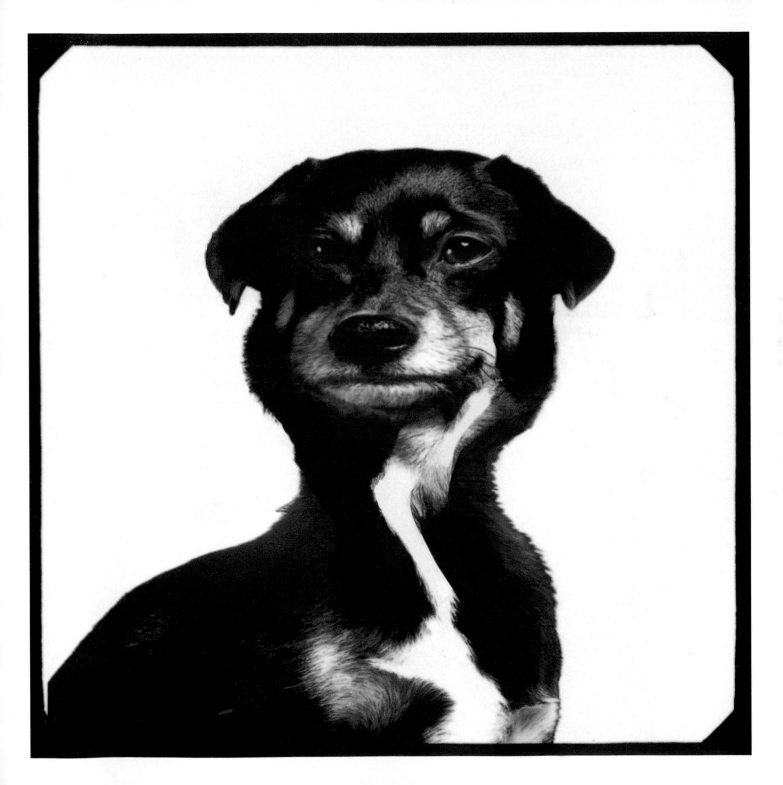

Shouldn't that be a picture of me?

I've been framed and hung more times than I care to remember and yet every time I see a portrait of myself spotlit on a wall, a wave of exhilaration sweeps over me like brushstrokes over canvas. I'm only human-ish. Get the most out of your art, dear reader, by making most of your art about you.

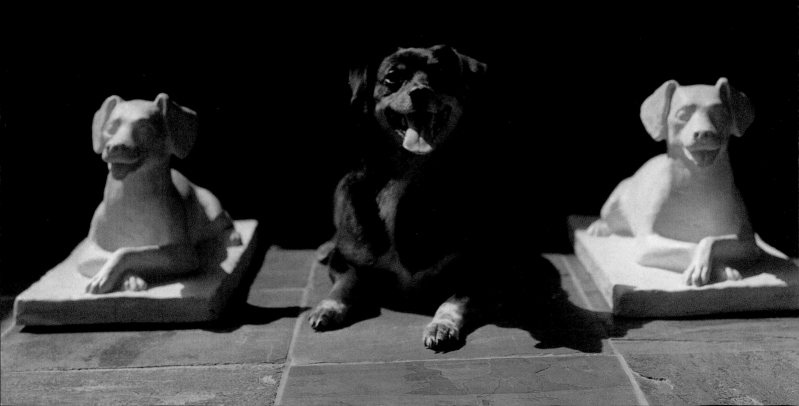

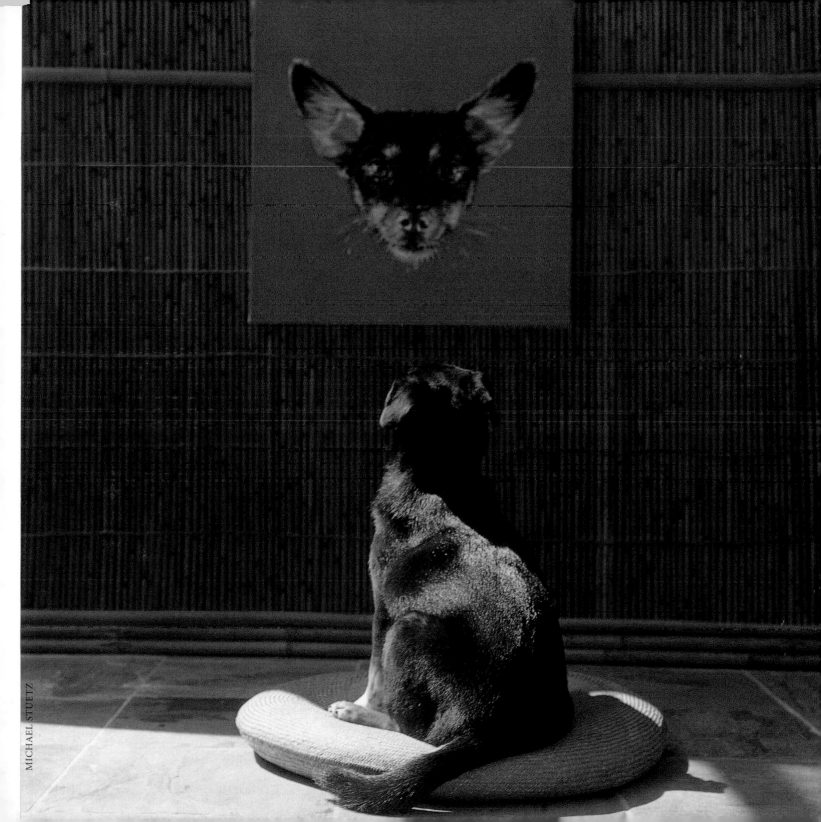

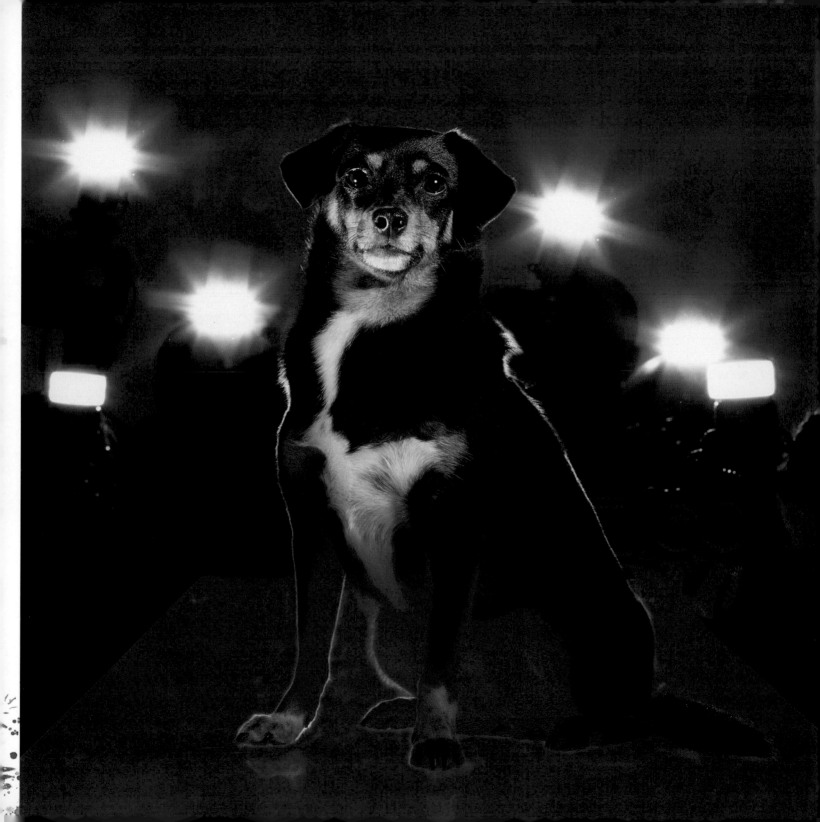

PARTING POINTERS

A red carpet regular's guide to
hogging the spotlight

Having completed your journey from the gutter to the runway, it's now time to prepare yourself for the inevitable pop of the paparazzi's flashbulbs. In order to become an overnight media sensation I advise you to:

- Attend the opening of windows, handbags, and oysters.

- Regularly practice your smile in the mirror. (Instead of saying, "cheese," say "beef.")

- Learn how best to stand when being photographed. (In my experience, you should stand as far from the camera as possible. Distance is everyone's best feature.)

- Never wear anything bigger than a postage stamp.

- Practice exiting a limousine. (Remember, girls, legs together, lips apart.)

- Frequently pull my book from your purse, hold it up to the camera, and announce to the press, that, "I learned everything I know from a fabulous little bitch called Sweetie!"

Love,

Sweetie

ACKNOWLEDGMENTS

My rags to riches journey from the gutter to the runway would have ended abruptly in the gutter if it weren't for the generous support of my many friends, fans, butchers, bodyguards, and bartenders. I would like to thank the following for their invaluable contributions to all things Sweetie:

Val Nehez for literally plucking me from obscurity. Mark Welsh and John Bartlett for adopting me as their "hairy daughter," warts, ticks, missing teeth and all.

The team at *Elle* magazine: The Publication Director and my primary portraitist, Gilles Bensimon; Editor-in-Chief, Roberta Myers; Art Director, Florence Sicard; and my heaven-sent editor, Anne Slowey, for tearing off my muzzle and encouraging me to bark.

The photographers who loaned their work: This book would be a lot slimmer if it weren't for the generosity of photographers, Gilles Bensimon, Joy Bell, Fernando Bengoechea, Xavier Brunet, Dan Lecca, Matthew Mendenhall, Patrick Mulcahy, Vicente Pouso (a.k.a. Vinnie), Valerie Shaff, Michael Stuetz, Cleo Sullivan, and Austin Young. Thanks to each of you for capturing my eerie beauty in your own unique fashions.

Warner Books: My marvelous editor, Diana Baroni, for her enthusiasm, encouragement, and, upon occasion, much needed discipline. And to Publisher, Jamie Raab; Art Director, Jackie Merri Meyer; and Molly Chehak for their boundless faith.

Ruben Toledo, the talented artist who captured my hairy essence and served it up with wit, whimsy, and a heaping dose of inspired lunacy. And to Isabel, who graciously shared her husband and her lap.

Memo Productions: My wonderful designer, Douglas Riccardi, who applied his discriminating eye, deft style, and love of white space to every page. And Rachel Urkowitz for her talent and her way with prosciutto.

Barneys New York: My mentor, friend, and biggest supporter, the always-encouraging, always generous, always right, Simon Doonan. And to Mark Vitulano, (that rare beast who actually enjoys doing windows), and P.R. maven Dawn Brown.

IMG Models: My agent, Ivan Bart, (who stuck by me through fat times and thin), Chuck Bennett, Maja Edmonston, Alvin Fung, Jaclyn Holland, and everyone else at IMG who contributed to my huge-ish success as a top-ish model.

Mary Evans Inc.: My legendary literary agent, Tanya McKinnon, who helped polish my rough edges, hone my prose, plot my strategy, and launch me on an unsuspecting public.

And to the sensational Sweetie support team: Jonathan Adler, (creator of the couture dog bowl), Mark Musters & Co. for their unswerving generosity, Pietro Luigi Roncalli for the couture corset, Ross Sutherland, for his creative input and always inspiring wit, Harry Winston for the rocks, Orlando Pita for the wigs, The Hotel Principe di Savoia in Milan, "my home away from home," Neal Decker, Rick Kantor, Conrad Rippy, Rob Goldman, Elaina Richardson, Marin Hopper, Jason Weisenfeld, Jeffrey Schneider, The A.S.P.C.A., The North Shore Animal League of America, The Humane Society, Tails in Need, Veuve Clicquot, the inventor of the steak and kidney pie and lastly, to the fashion industry, without which I would never have a thing to wear or a word to say.

The End